t at Mary Lasker's coc

paparazzi were trying to get Al's attention, yelling Al,
ed with old Rat Pack buddy Dean Martin. Frank and Dean raised $ 750,000 for the dreaded eye dis
teve was hot to get Frank and Dino for this benefit because he just became
taken out w/ heavy security The
performs for Ron Galella without him asking, all celebrities should be
photographed rockstar Roster of Frank Sho McFarland Jr. Everywhere Hol Los Angeles ent
ns Christian Anderson fairytale in
ember 19, 1967: Stunning Joan Collins, here h
ended the premiere of the film "Dr. Doolittle
a benefiting the American Indian development Association at the Waldorf
chmulbach got this shot of Ron Galella wearing a helmut in the corridor
s conference to annouce the First Gala benefiting the A

Brando miled, but kept a str

ut-of-court settlement for $.40.00 was reached in Galella's favor later. But Galella took no mor
on Avenue in New York City without her sunglasses on. I was
w that woman!" I told the cab driver
ed a cab to get in front of her so she couldn't see
For one, Jackie's instincts were all wrong; instead
paparazzi style; offguard, unrehearsed,
and quipped "Are you pleased with yourself?
e, my favorite, most famous photo of Jacki
ing photos o screening on E.
ie and John going hom

in Central Park

Lee and niece sho
update on Bowie. He is a star of many faces, an supreme pop chameleon. For more than a decade
The Elephant Man (1980). Bowie is currently on a worl
Her name is Jee-Ling and she is featured wi

during transfer from limousine to Olympic station wagon, with agent. She's going to Paris for
elds her face with bouquet upon se
photographer Ron Galella after the Eddie Rabbit & Sandra Locke opening
arden
12, 1971. Whoops Raquel! You better button up! Raquel Welch attend Polly Bergen's party at her
o it here and in Europe but husband Andre says Raquel will be in a new play, which will open fi
tes at the premiere party of a Su
the SHARE Benefit party at the Santa Monica Civic Auditorium
velopment Association at the Waldorf Hotel in New York City.
n the corridor of the hotel as Brando December
Chinatown breaking his jaw and knocking out his teeth. An
husband Anthony Fe
Hollywood celebrities who attended the Ronnie Lane Multipl
rammy Awards at the Uris Thea
as they returned to their suite of rooms at the
Spring Gala, chaired by Iv
evening was expected to raise some $1 million Ivana Trum
trimmed in gold!
onna celebrated he
She sported platinum locks and was surrounds by heavy s th
ral minidress and her Dick Tracy co-star, Warren Beatt his
safari-like train ride through the crowded park and ended drawing mo stares and
dy's first visit to the zoo and following an afternoon of 90c plus heat, he seemed delighted to
o party after "Golden Rainbow" opened at the
ombarded by admiring fans.
dler at the Grammy A
society Oct 5, 1967: Penelope Tree, model at Camelot premiere. Mo
night says dancer at Studio 54
ctober 9 1975: The 40th Anniversary of the American Museum was held at
New York City. Dozens of art notables turned out for the special eve

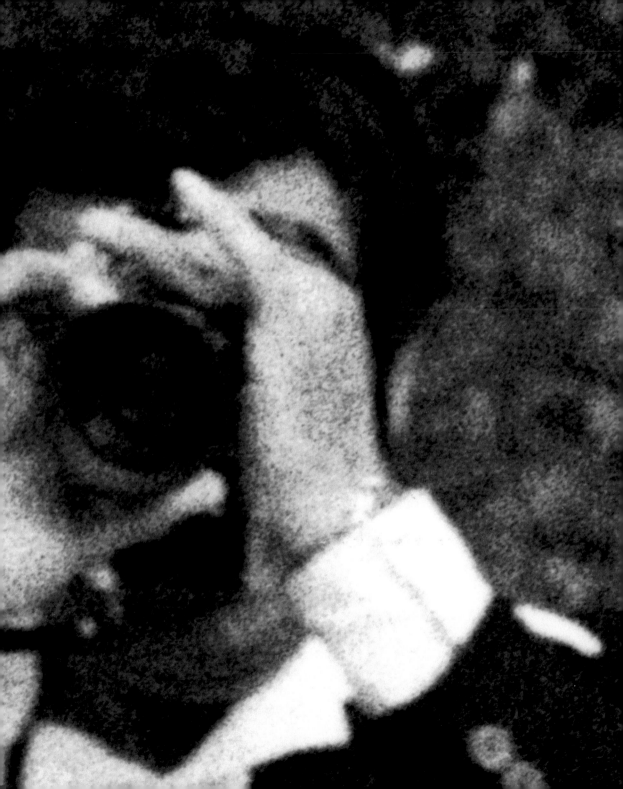

ron

galella

exclusive

diary

There's an old Italian saying, "Che Sarà, Sarà ... Whatever will be will be."
Early in my youth, I asked
myself-"What will I be?" I believe we shape our own
destiny - we have many choices, we have many
opportunities, we cannot
rely on luck alone or at
all. In this life you are
either somebody or nobody. My Italian teacher, Mrs. Costanza, said that. I had to
be a somebody no matter what,
choosing what to be was very difficult. In High School I
was most interested in Geometry, Biology and Art and got all A's in all three.
Geometry led me to want
to be an architect, Biology a dentist and Art
an artist. In high school I
majored in art, and graduated
in June 1949 with an academic diploma which prepared me for college. I had no
money to go to college, coming from a poor
family of 3 brothers and a sister. I was born
in January of 1931 in the middle of the Great Depression. My father, Vincenzo,
born in Potenza, Italy, came to America and married my
mother, Michelina, who
was born in Hoboken, NJ to Italian parents. My father had a trade as a
cabinetmaker and had only two jobs in New York City,
Steinway Piano Company
and The National Casket
Company. He was a hard working man. He bought a house in the North Bronx, where
after graduating high school, I had an opportunity to
become an architect. I received a two-year scholarship from
Pratt Institute in New York. They offered the scholarship although I was weak in
math. I turned this opportunity down because

whatever I would choose to be, I would be the best.

I was an idealist, I always aimed high. In 1949 I faced the real world and
began working for a living. My
first job was delivering photographs for a photo-finishing
company across from Foley Square where the Federal Court was located. Little did
I know, in 1972 I'd be in that
court building with a 26-day court battle with no other than
Jackie Onassis. After a few months, I got a better paying job- $125 per week
bending and painting metal shelving for a
sheet metal company.
One day we delivered an order of shelves to the Associated American Artist
Ceramic Division on 42nd
Street next to the NYC McGraw-Hill Book
Company, which would publish my second book, "Offguard" in 1976 though of course
I did not know it at the time.
Upon seeing ceramic pottery and figurines, I immediately felt at home. I could
fulfill my dream of being a ceramic artist, a Michelangelo. I asked the boss,
Mrs. Serber, for a job
and she said I could start Monday with a
salary of $60.00 per week. Because I was ending a $125.00 per week job for one
paying only $60.00 per
week, I did not quit my sheet metal job until I saw how I liked the ceramic job.
While working on Monday, my
old boss came in to set up the
shelves and Mrs,, Serber said, "I got your man
working. This was my
most embarrassing experience. The job was creating reproductions of famous
American artists with plaster molds. On my
own time, I learned to use the
pottery wheel and turned out more creative things. I was

becoming a Michelangelo: I sculptured a life-size head of myself looking in a mirror. Then I sculptured my heroes– D'Artagnan with the Three Musketeers, Cyrano de Bergerac and Don Quixote. For me it was worth quitting the higher paying job. I believe one should follow their heart and do what one loves and not do things just for money. Money will reward those who excel no matter what field they choose. I was happy to be a ceramic artist but this was all going to change. In 1951, I faced the draft due to the Korean War. To avoid being drafted into the US Army for 27 months, I enlisted in the United States Air Force for four years where I would have the opportunity to learn a trade and see the world. In the Air Force, the only career training related to art was photography so I got my start in photography by graduating from Lowry Air Force Base's School of Photography and Camera Repair. After school I was based in Orlando, Florida for 3 years. I bought a set of Encyclopedias with photography from my Sergeant for $60.00. I studied all the great photographers in my pare time such as Henri Cartier-Bresson and W. Eugene Smith, two of my favorites who inspired me to become a photojournalist. One thing I learned in the Air Force: If you want to accomplish anything, like getting a "hop," you must go to the decision-making ranks such as the pilots. I had no trouble getting "hops" on Furlough or weekends, just by asking the pilots directly. Later in my career, I applied

this technique by confronting and asking the celebrities for photos directly instead of going through their press agents and managers. One time in 1977 I had an assignment from the Star to photograph Cher for a cover with no photo shoot set up. Cher knew me so I rang her doorbell at her Beverly Hills home and asked her for the photo opportunity. She told me to come, back the next day at 5pm. That's how I got the cover of Cher with her baby, Elijah Blue. Since I was not going to be shipped to Europe, I decided to go on my own using military "hops" and gave myself a big photo assignment: Europe! So, on July 2, 1954, during a 45 day Furlough, I started hitch hiking from Pinecastle Air Force Base to Washington DC to Naples, Italy. I only spent $150.00 on minor travel, hotel and food expenses. I toured nine countries, hopping over 20,000 miles taking pictures, over 500 stills and 500 feet of movie film. This was my first taste of fame- I made the front page of the base newspaper and the Air Force Times "Pinecastle Airman 'Hops' 20,000 Miles in 33 Days" with a photo of me at the Trevi Fountain in Rome with a caption of "The Happy Wanderer." In 1955, after four years in the Air Force as a till and aerial photographer, I had to decide, under the GI Bill, whether to further my career as a photographer or as a ceramic artist. I chose photography because it is the modern art of today along with architecture. Painting and sculpture had had its day in the past. Artists like Michelangelo and DaVinci had to draw

painstakingly for hours whereas with the click of the shutter with a camera we get instant drawings- drawing with light. This advantage permits the photographer to concentrate on the subject's expression and gestures. In 1955, I decided to make photography my career by going to the Art Center College of Design in Los Angeles, California. In Hollywood, I used to give myself photo assignments- that of crashing premieres and parties. In 1957, I crashed the premiere of "Guys & Dolls." In one night I photographed Frank Sinatra, William Holden, Lauren Bacall, Vivian Blaine, Lucille Ball, Gregory Peck and other stars. This was my first taste of the world of glamour and I loved it! In 1958, after graduating from the Art Center College of Design with a professional arts degree in Photojournalism, I returned home to the Bronx and built a photo lab in my father's house. In 1963, I worked as a lab technician in the Time-Life lab and learned to be a better Black and White printer. I excelled in this. Since then I have always done my own printing. While working, I continued freelancing photographing celebrities at Broadway openings and movie premieres. As a freelancer, you must come up with good pictures and also be able to sell them. Unlike staffers who worked 8-hour days and went home, I usually worked 80-hour weeks. For me it's my life's work and I love it. I'm a workaholic. In 1967, I just photographed Jackie and Andre Mayer at the Wildenstein Gallery in New York City. The gallery was jammed with people and as it was impossible to get good

pictures, I waited outside for departures and photographed Jackie and Andre leaving the gallery. Another photographer, Sante Vassali asked where my car was parked. We went to photograph Jackie at her Fifth Avenue apartment. Now that I knew where Jackie lived, I saw the opportunity to photograph her by staking out her apartment on other occasions. She would become my favorite subject. She was my ideal subject because she was always mobile, jogging, bicycle riding and going to the ballet and to restaurants. There were two court battles. One was in 1972, where I spent 26 days in court. The second was in May of 1982. I spent one week in court where I was ordered by a biased judge, Irving Ben Cooper, appointed by John F. Kennedy, to stop photographing Jackie and her children. The court battles consisted of accusations of invasion of privacy and harassment, although the pictures showed that she loved to be pursued and photographed. She was a great actress in court. She got what she wanted- a court injunction, which kept me from approaching and photographing her and her children. I had to keep at least 25 feet of distance. Later, for the last 13 years of her life, I wasn't allowed to photograph them at all. To avoid a $125,000 fine and seven years in jail, the judge revealed his bias when both lawyers, hers and mine, agreed on a fine of $5,000. "No", said judge Cooper, "make it a $10,000 fine, and never

take another photo of Jackie, John Jr. and Caroline, no matter what distance". Never did I **photograph Jackie the last 13** years of her life. I have not photographed Caroline to this day. On September 7, **1995 John Jr. launched George** Magazine with a press conference and granted me permission to photograph him in **spite of the injunction. Later on September** 16, 1996, he signed an agreement allowing me to photograph him in public places **until he died. Being a journalist himself,** he was sympathetic to me even though his mother won a court ruling in 1982. I've **been trained to be a good journalist, to walk** with the confidence of a Life photographer, to photograph celebrities in all **public places, that's the easy part. Now when** it came to photographing Jackie I became a paparazzo because she did not go to **many public events and was not** easily accessible. Paparazzi is a tool, a method of going to celebrities, staking them out and photographing them in public **places without a publicized event. I became a** self-styled paparazzo and on my letterhead said the ideal qualities are: exclusive, offguard, spontaneous, no appointments, the only game. **Sophia Loren once said to me, "You are not a paparazzo".** She's right because the paparazzi she knows are bad. They seek scandal and they provoke celebrities with the purpose of creating incidents **that make for salable photos. My approach is to catch stars by surprise.** Rarely do I use telephoto lenses. I prefer normal or wide angle lenses and meet the stars face to face to record their reactions- it **becomes more like candide portaiture. Today**

the industry has changed for the worse with too many P.R. agents, too much security, too many policemen and too many photographers. All these become obstructions in photographing celebrities at events. In the good old days I had the freedom to shoot great shots like the 1975 Grammy Awards at the Uris Theatre in New York City. I did not have to call to get on their list for the event, unlike today. One public relations representative set up the big shot- David Bowie, Simon and Garfunkel, Aretha Franklin, Yoko Ono and John Lennon backstage. On my own I set up a shot of John and Yoko. Then at the Essex House for thr post-party that I crashed, I set up a shot of John Lennon and David Bowie. I had no interference and I was not thrown out, like would have happened today. It was a bonanza night! I do this work because I love what I do, I take pride in my work. It represents me. In my career I had many things against me: a restraining order from Jackie, John Jr. and Caroline, a broken jaw and minus five teeth by Brando, a hosing by Brigitte Bardot's friends, a beating by Richard Burton's bodyguards and later being thrown in a Mexican jail (I sued Liz Taylor, Richard Burton and the movie company and lost). In the face of all physical, legal and moral attacks I have endured. I have survived and got the shot. In the end, that's what counts, like millions of others living vicariously though seeing those many images, we all become voyeurs. That's the great thing about this magic art- an instant of time and place, frozen for posterity. It's genius; it's beauty that will remain long after I'm gone.

Ron Galella, September 2004

**THIS IS AN ORIGINAL
PHOTOGRAPH BY
RON GALELLA:**

[signature]

RON GALELLA

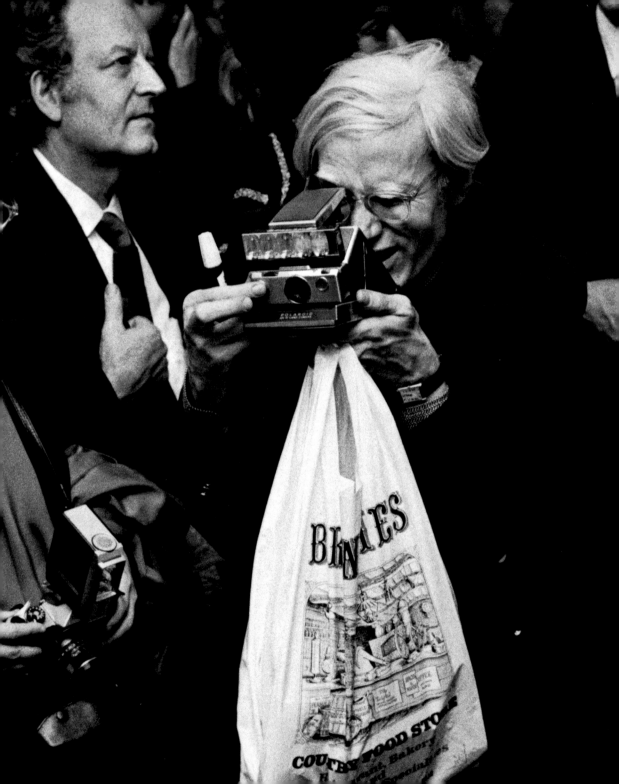

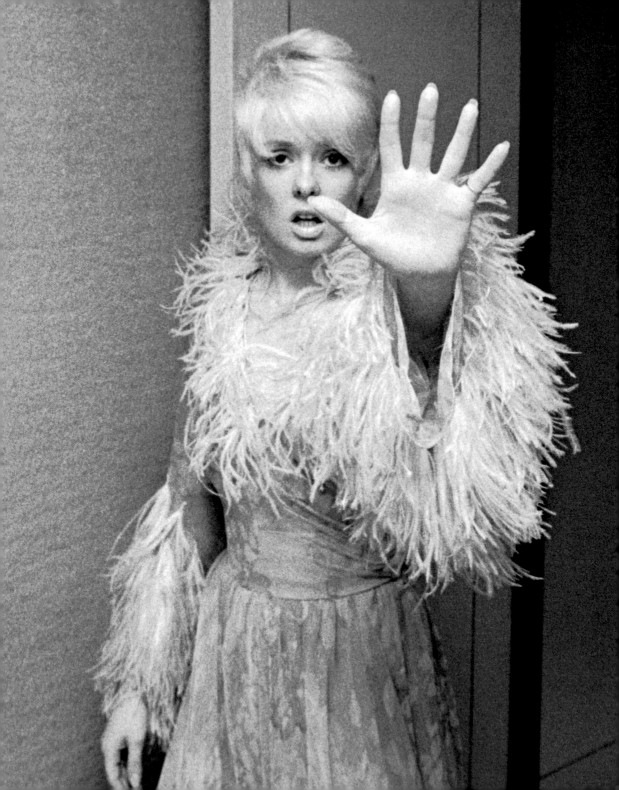

exclusive
diary

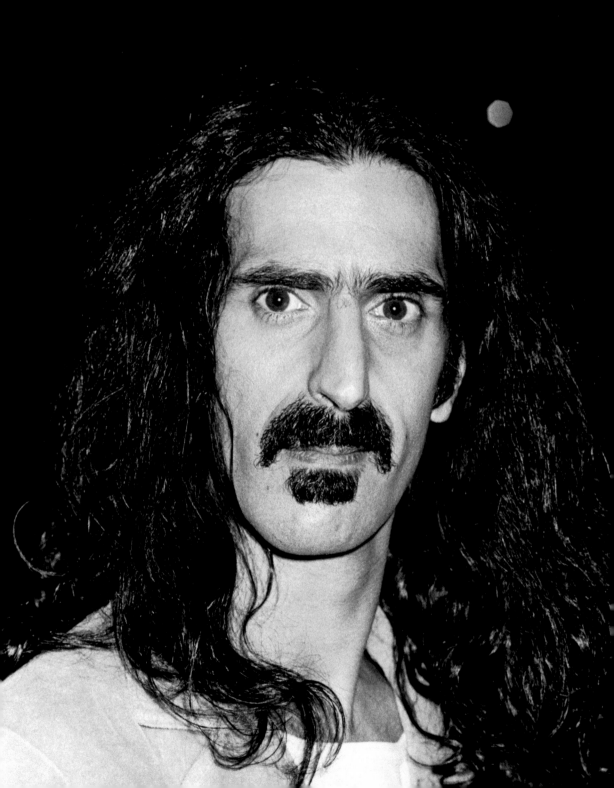

Oct. 30, 1978:
Frank Zappa
at the
St. Regis Hotel,
New York City.

October 9, 1975: The 40th Anniver-
sary of the American Museum was held
at the Hayden Planetarium in New
York City. Dozens of art notables
turned out for the special evening
including internationally know sur-
realist, artist SALVADOR DALI. He
was snapped with ULTRA VIOLET of
Andy Warhol's Factory fame. Her real
name is Isabelle Collin Defresne.

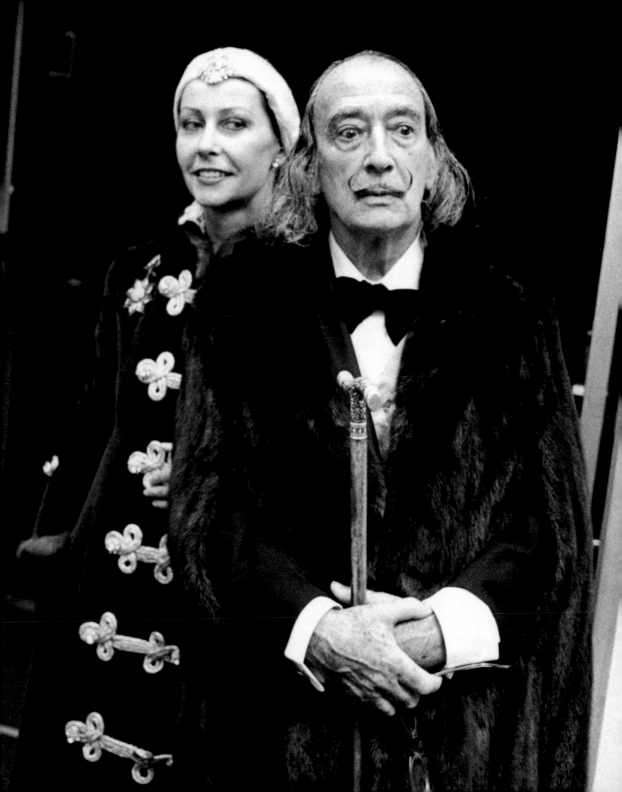

September 1968:
Zoom Zoom Nightclub
is the hottest of
hot spots for late
night action in
St. Tropez, France.
Globe-trotting New
York based celebrity
photographer Ron
Galella travelled to
the South of France
to photograph sex
siren and screen
legend, Brigitte
Bardot. The
legendary French
beauty departed
the club with an
unidentified
companion.

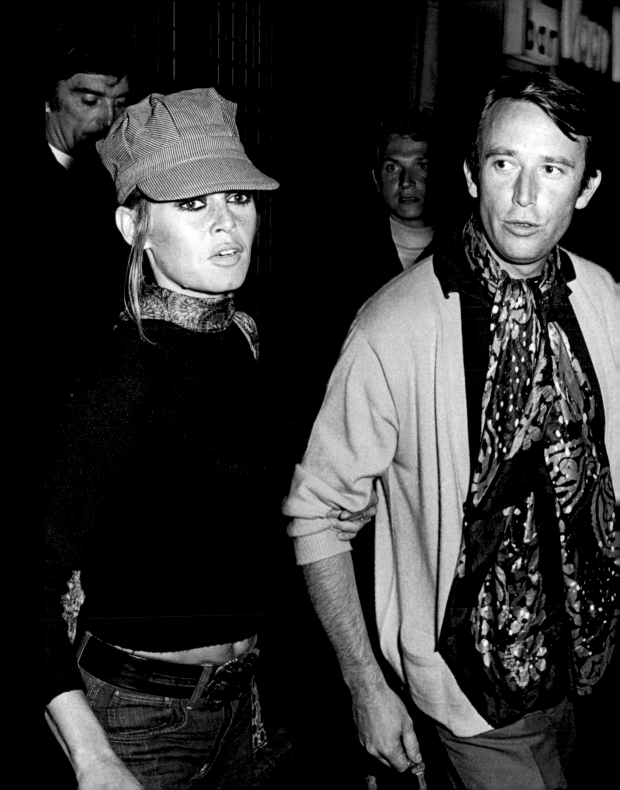

June 12, 1983:
Bronx, NY. The
jungles of Africa
are too hot and
wild for artist
Andy Warhol, so
he chose to see
exotic animals
during a Sunday
afternoon at the
Bronx Zoo. Andy
and a companion
took a safari-
like train ride
through the
crowded park and
ended up drawing
more stares and
responses than
did the exotic
species housed in
the world famous
zoo. This was
Andy's first
visit to the zoo
and following an
afternoon of 90%
plus heat, he
seemed delighted
to head back to
civilization!

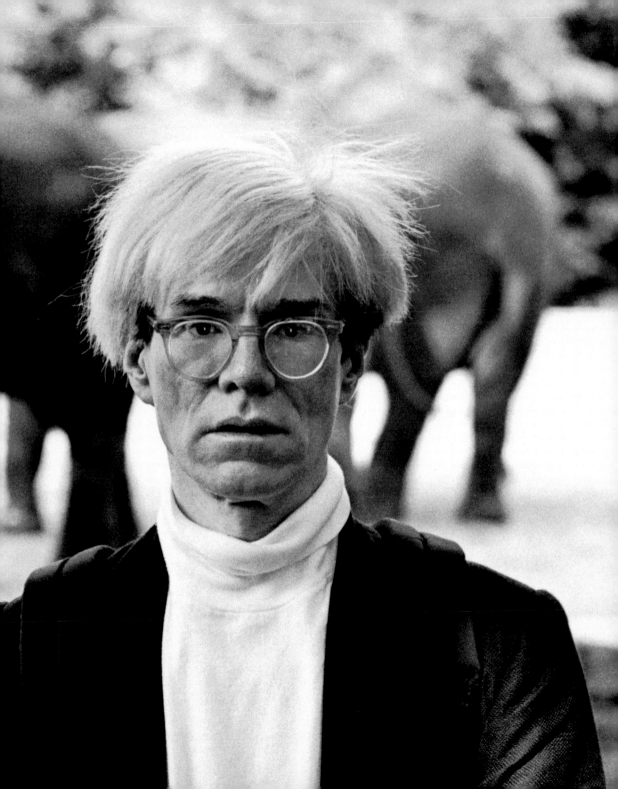

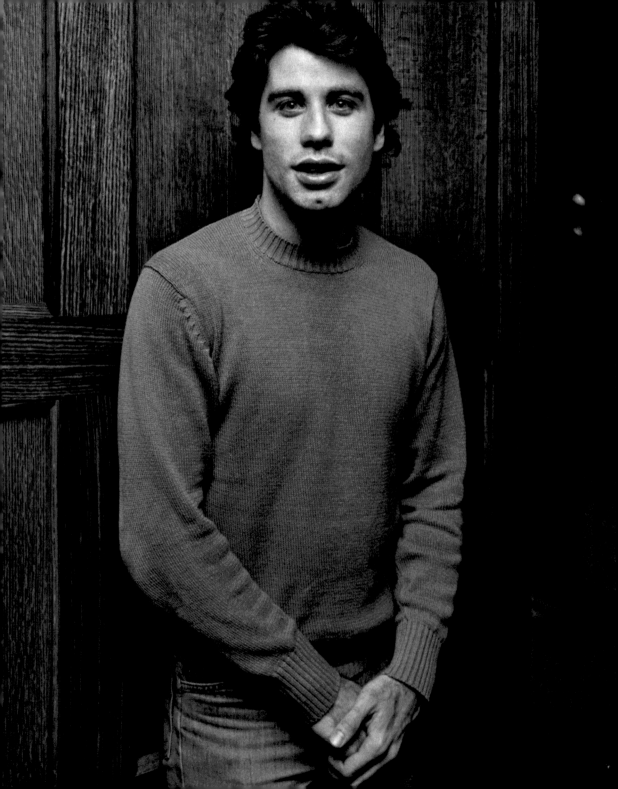

July 7, 1981: John Travolta in the lobby of
Brian DePalm's NY apt. where he believed a
party would be given in his honor, but was mistaken!
The party was in between the private screenings
of "Blow Out" & Travolta attended the 8:00 perfor-
mance & missed the party. RG told Travolta he thought
"The movie was great & would be a big hit for him"
Travolta posed for RG for 10 minutes. Meanwhile,
Travolta's limo went to pick up Brooke Sheilds &
she met Travolta in the lobby but they would not pose
together.

March 21, 1978:
Warren Beatty
& Jack Nicholson
at the Mabel Mercer
concert at Dorothy
Chandler Pavilion
at the L.A. Music
Center.

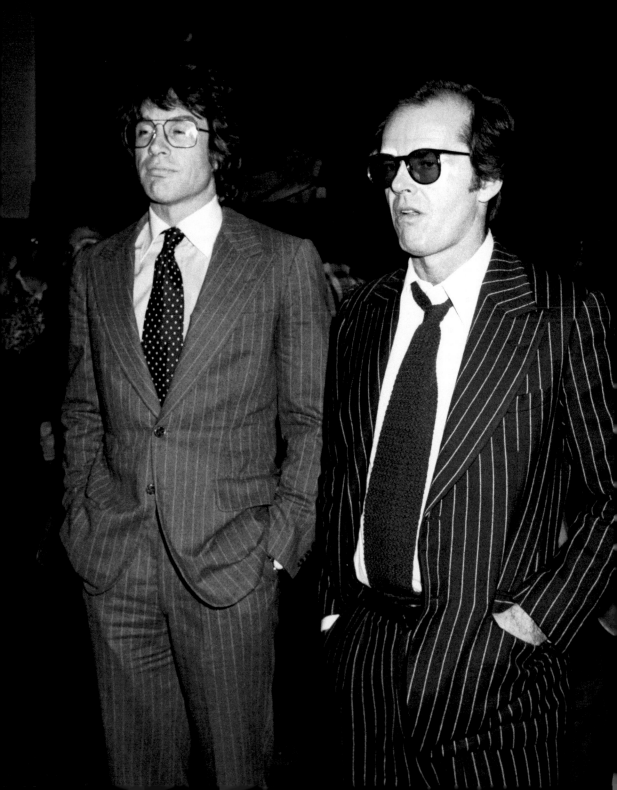

April 18, 1984: A cigar smoking Tom Jones was snapped at the Beverly Wilshire Hotel in Beverly Hills, Ca. where he attented a gala evening honoring His Royal Highness Prince Andrew. The event was for the benefit of the British Olympic Association/USA. The singing star was born Thomas Jones Woodward on June 7, 1940 in Pontypridd, Wales.

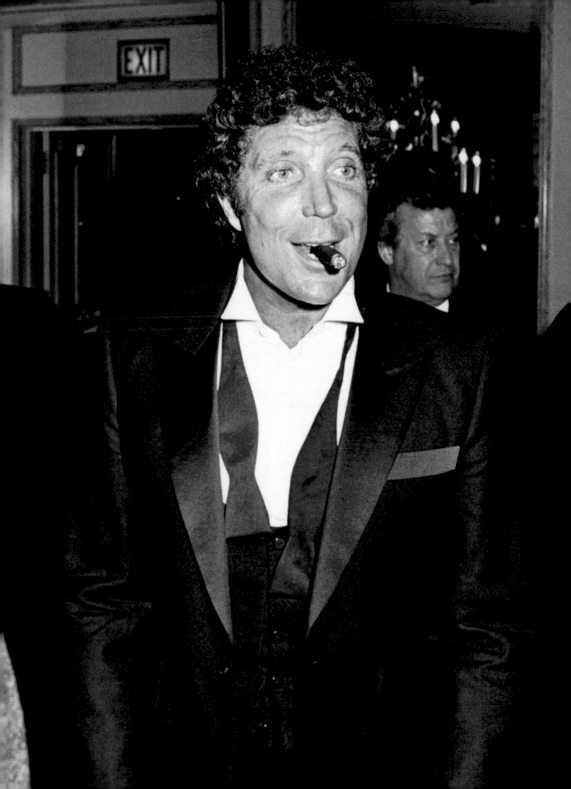

March 31, 1974: Singer/actress Ann Margret made a stunning entrance when she arrived at the Dorothy Chandler Music Center in Los Angeles, California to attend the Academy Awards. Her head was wrapped in a glittery, sequined turban and during the course of the evening, she turned lots of heads!

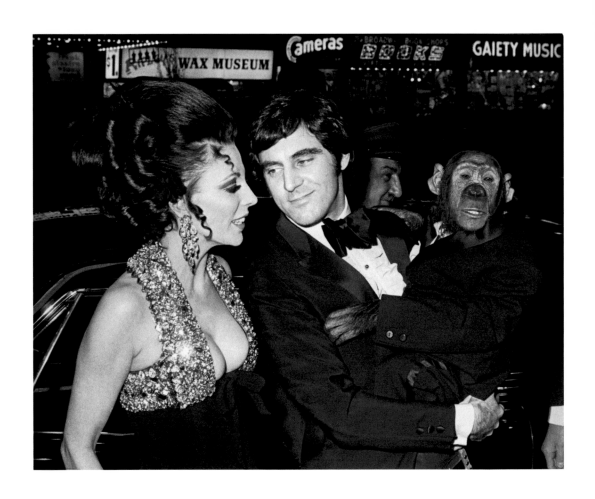

December 19

Stunning Joan Collins, here husband Anthony Newley and a well dressed chimp friend at Lowe's State Theatre in New York City. They were among the many celebrities who attended the premiere of the film "Dr. Doolittle". The actress wore the most breathtaking gown of the evening.

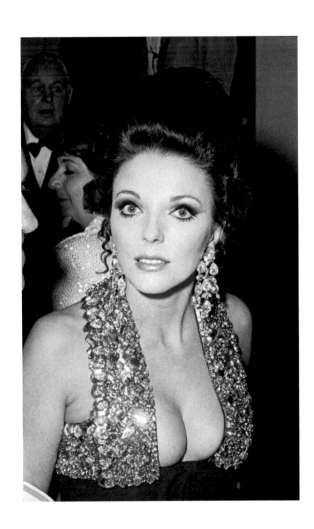

1967

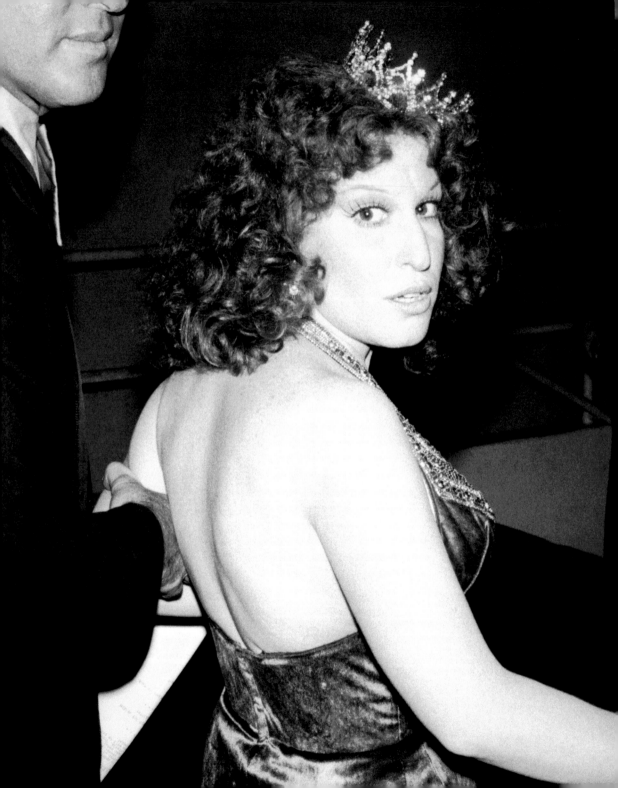

Feb. 19, 1977:
Bette Midler
at the Grammy
Awards at
the Hollywood
Palladium.

May 9, 1982:
The stormy on
again off again
romance of Farrah
Fawcett & Ryan
O'Neal seems to be
on again as they
attended Interview
Magazine Editor
Bob Colacello's
birthday party.
The $ 3 million
complex owned by
Ricardo Amaral &
Jean Claude Pujol
is already the
talk of the town
called Tucano
Restaurant. They
also have another
new club in the
works called Club
A which is not
opened as of yet.

Dec. 4, 1981:
The ever so hard to
photograph, Ryan O'Neal
& Farrah Fawcett at
Faberge party at Studio
54. It is rumored that
Ryan has given Farrah an
engagement ring & they
plan to wed in March.
When a mass of photog's
approached Ryan &
Farrah, Ryan said,
"I feel metal meaning
the cameras".

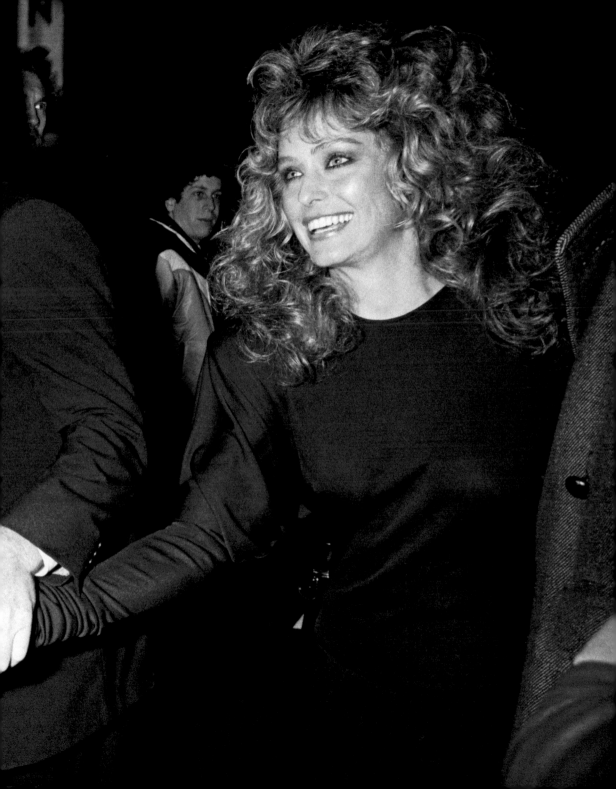

May 15, 1974:
Robert Redford at
Mary Lasker's
cocktail party in
New York City for
Rep. Wayne Owens.
Ted Kennedy also
attended.

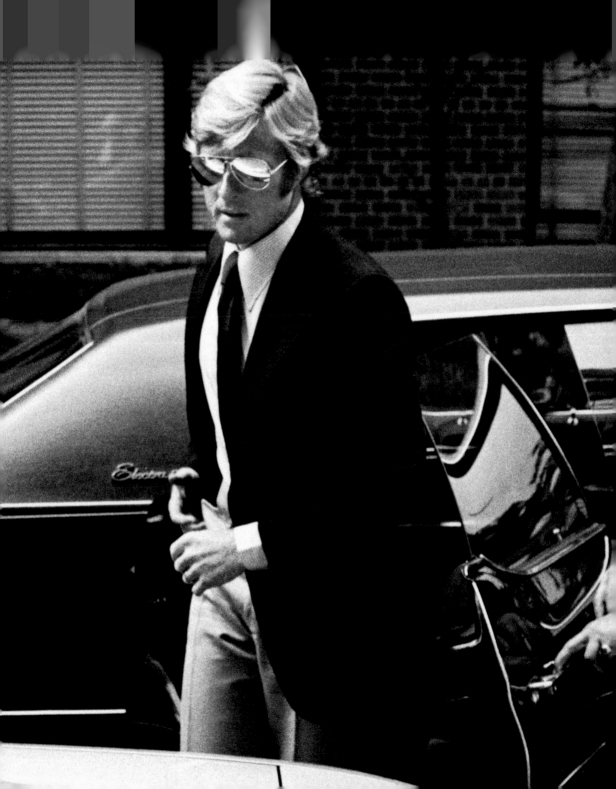

1968:
Julie Christie
off the set of
"In Search of
Gregory"
filming on a boat
in Lake Geneva
Switzerland.

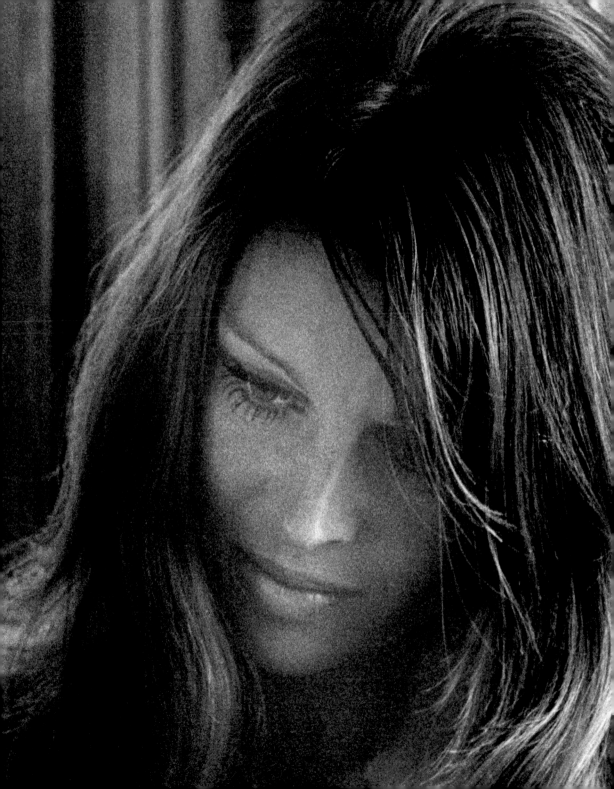

Feb. 1, 1979:
Clint Eastwood, his son & his daugther
spitting at photographer Ron Galella after
the Eddie Rabbit & Sandra Locke opening at the
Palomino Club in Los Angeles, California.

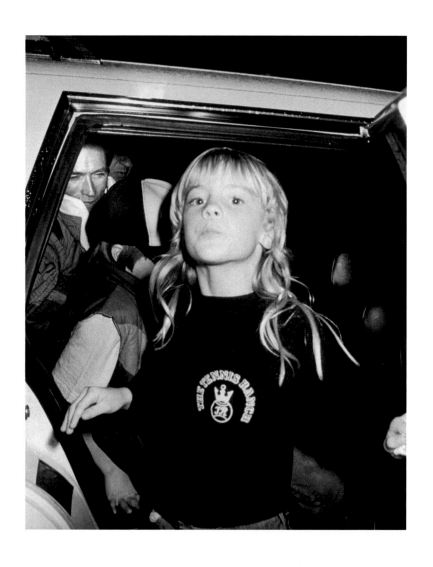

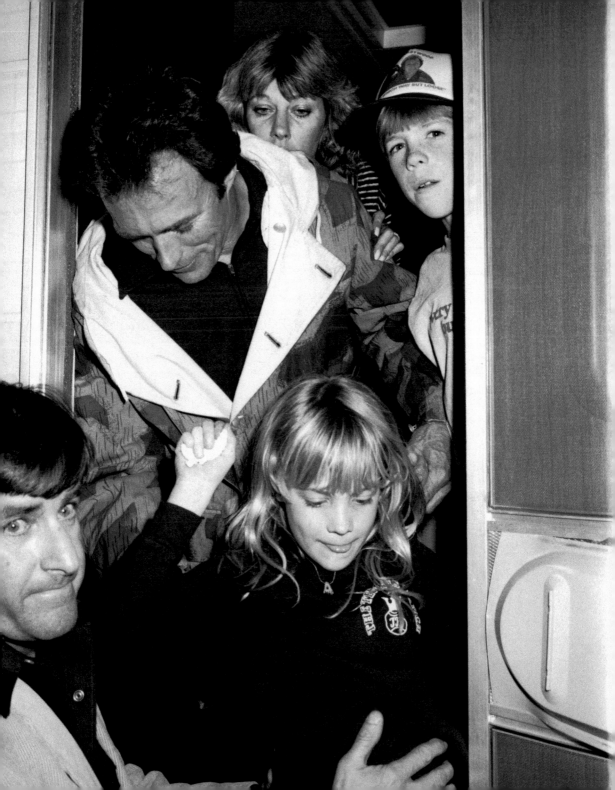

March 1, 1975:
David Bowie
at the Grammy
Awards at the
Uris Theatre.

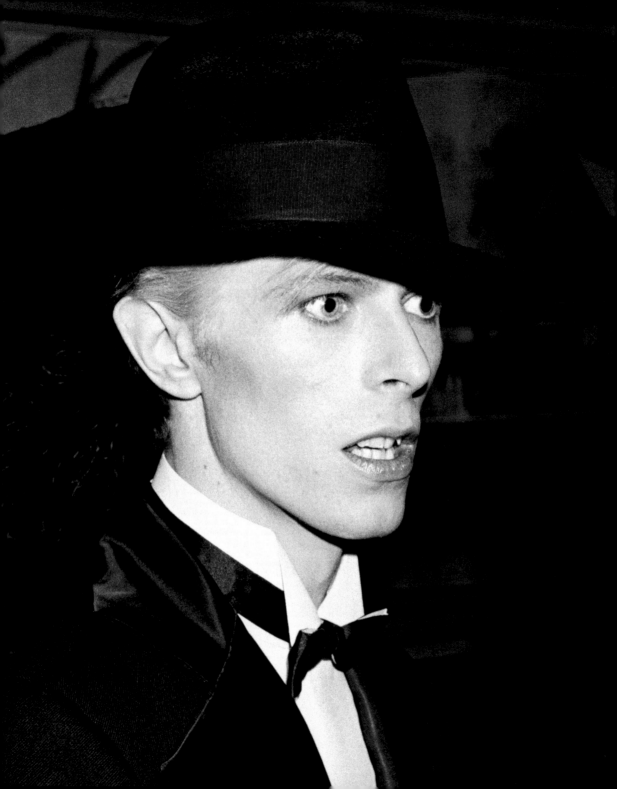

Oct 25, 1967:
Penelope Tree,
model at "Camelot"
premiere party at
Americana Hotel in
New York City.
Her mother is
Marietta Tree.

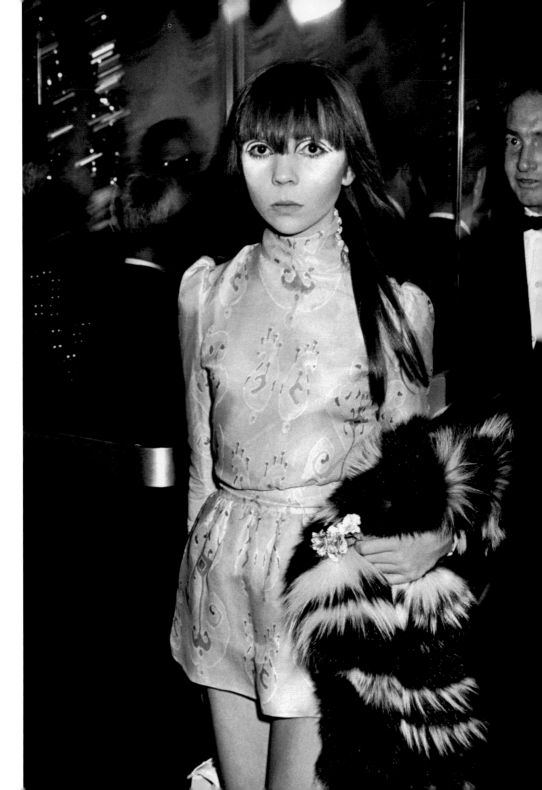

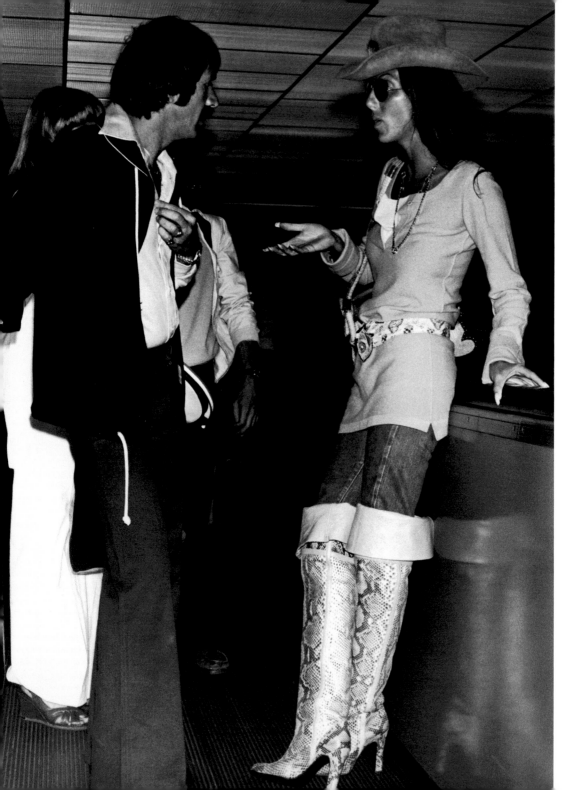

Jun 12,77: Sonny Bono and Cher Allman at L.A. International
Airport leaving for Toronto on the concert tour.

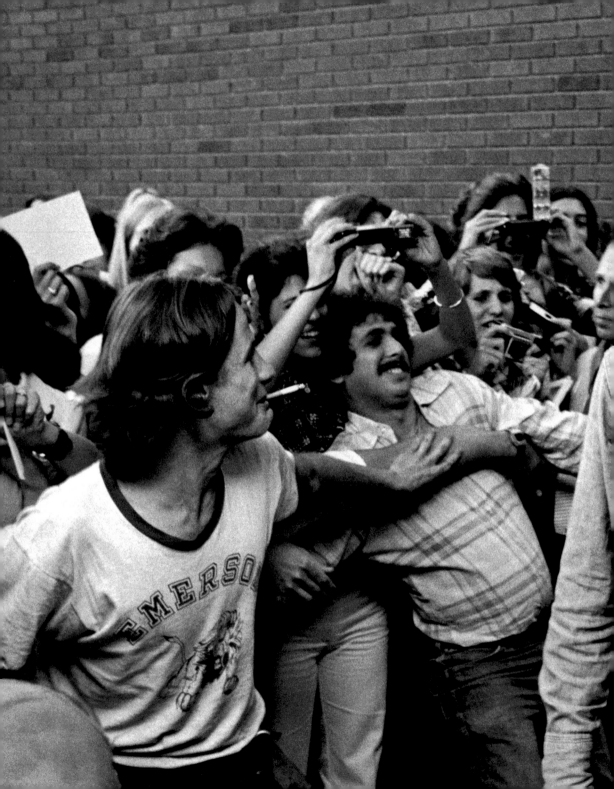

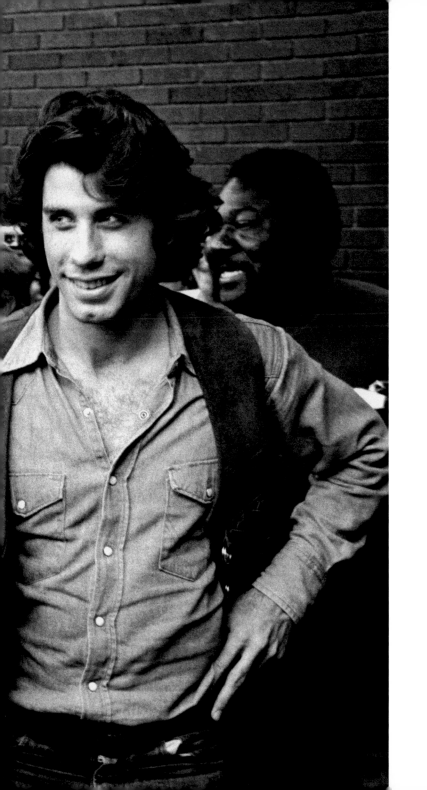

Aug 1,76: John Travolta plays it with a "who-cares" attit-
ude at the stage door of the Westchester Playhouse. While
bodyguards hold back the screaming fans, John acts cool
as if he isn't concerned. He opened in "Bus Stop."

April 5, 1979: A fan asked Warren
Beatty if she could kiss him & he
replied, "No, I have to watch out
for Galella!" at the Writers Guild
Awards at the Beverly Hilton Hotel,
Beverly Hills, California.

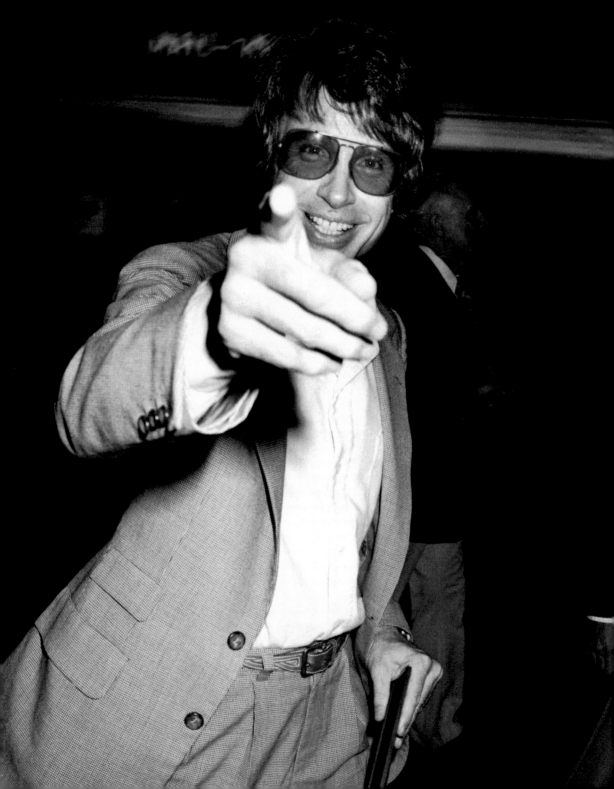

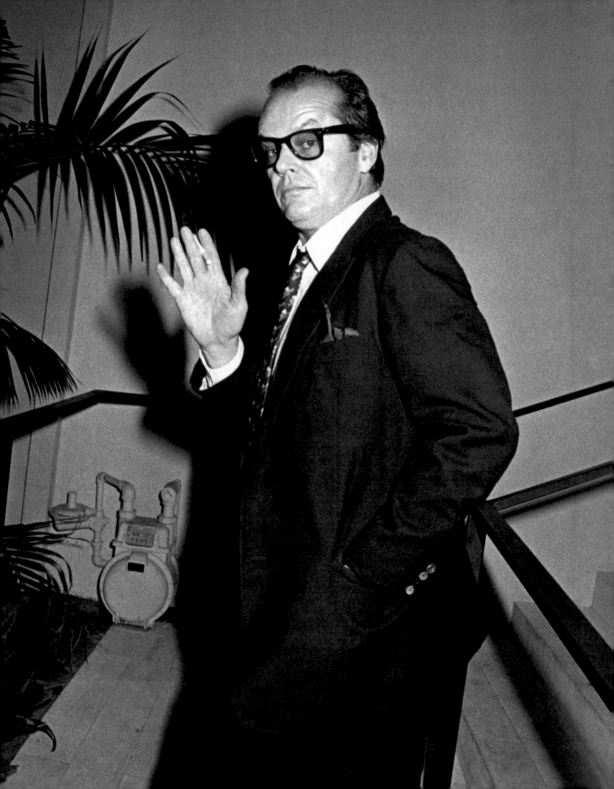

March 18, 1984: Actor Jack
Nicholson waved a greeting to New
York photographer Ron Galella
following dinner at Spago's Rest-
aurant in Hollywood, California.
The talented actor has received an
Oscar nomination for his role as
Garrett Breedlove, a drunken ex-
astronaut in "Terms of Endearment".
In 1975, Nicholson walked off with
the Oscar for his performance in
"One Flew Over The Cuckoo's Nest."
The actor still looks a little
beefy from his "Terms" role!

March 21, 1967:
Carol Channing at
Premiere of
"Thoroughly Modern
Millie" at Criterion
Theatre: Party at
Rainbow Room in
New York City.

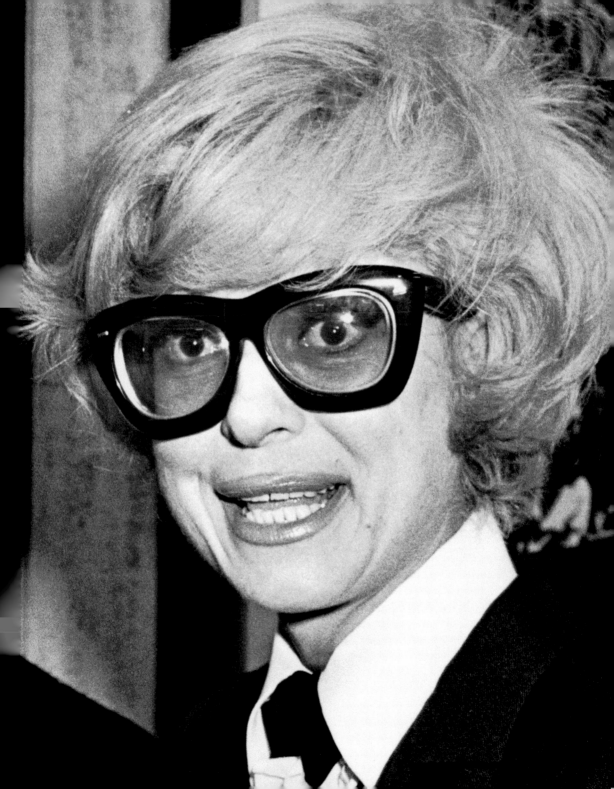

March 12, 1983: Warren Beatty, the
recipient of last years directors
award for his movie "Reds" presents
this years Directors Guild Award
to Sir Richard Attenborough at
The Directors Guild of America
Awards at the Beverly Hilton
Hotel in California. Warren is
always talking about making the
picture on Howard Hughes life-
maybe he'll get that project on
someday but right now he's tied
up in Ray Stark's film "Mermaid"
in which Warren will star and is
about a rich man who falls in
love with a mermaid.

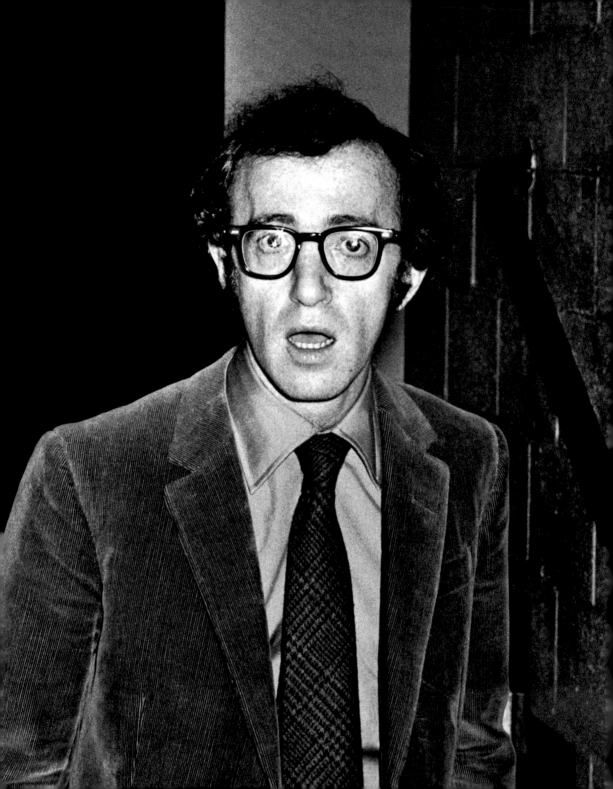

Oct 30, 1969: Madison Square Garden, Woody Allen at Mayor Lindsay Rally.

Nov. 26, 1980:
Mia Farrow enters
Elaines, after Woody
had already gone
inside, Mia & Woody
play their old games
again, entering &
leaving separately.

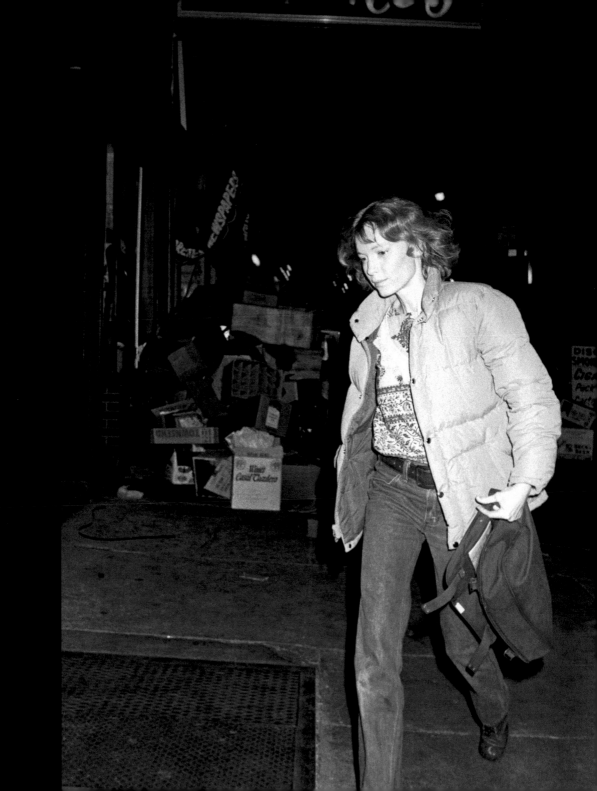

March 20, 1979: Is Gere Ready to do it again? Or is he ready to bare all as he did in his recent film "Breathless"? Gere was caught with his pants ready to come down at "The Champ" gala screening at MGM Studios in Hollywood. The 1983 update on Gere is that he should have played it safe before he decided to urinate in public last month, causing people on the streets of New York City to report him to the police. Gere was pulled into the station-house, receiving a minor summons which he can pay by mail. Gere is currently filming "The Cotton Club" which is being directed by Francis Ford Coppola and produced by Robert Evans. The film also stars black star Gregory Hines. After the "Cotton Club" Gere is signed by Paramount Pictures to play David in "The Story of David".

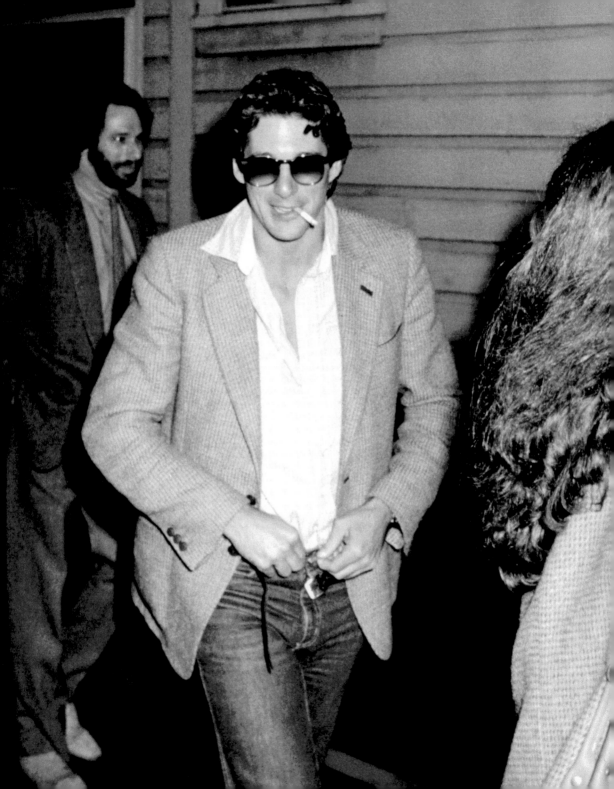

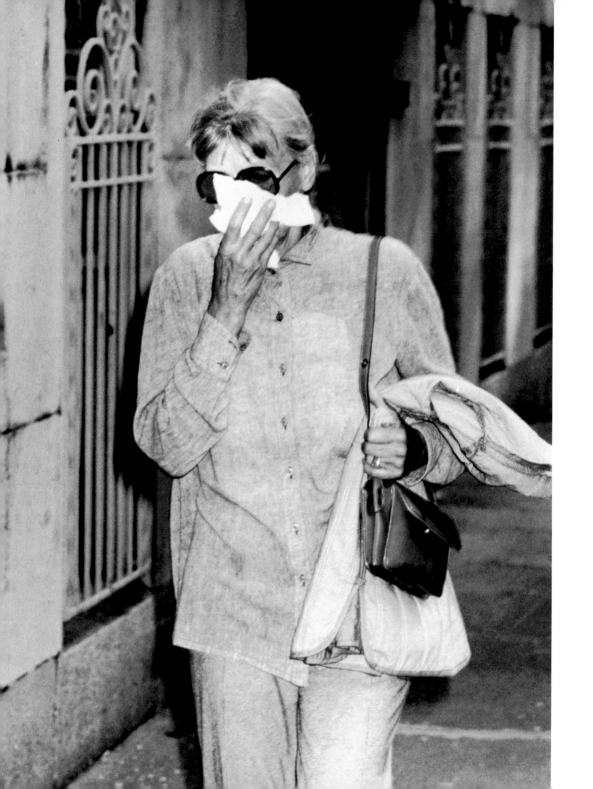

EXCLUSIVE

June 1, 1978: This photograph is truly an exclusive of the elusive and highly reclusive actress, <u>Greta Garbo</u>! She was headed towards her apartment on E. 52nd Street after at stop at Rizzoli Book Store in Manhattan. The reclusive superstar covered her face with a handerchief and said to Ron Galella, "Go away, go away!" How could RG go away? The last time he snapped her was over ten years ago!

February 16, 1984:
Princess Stephanie of
Monaco was snapped near
Bergdorf Goodman in
New York City when she
and her new brother-in-law,
Stefano Casiraghi
went to visit his family
shoe store nearby.
Throughout the day,
Princess Stephanie played
hide-and-seek and
peek-a-boo with
photographers who were
trailing the
Royal Princess around
New York City.

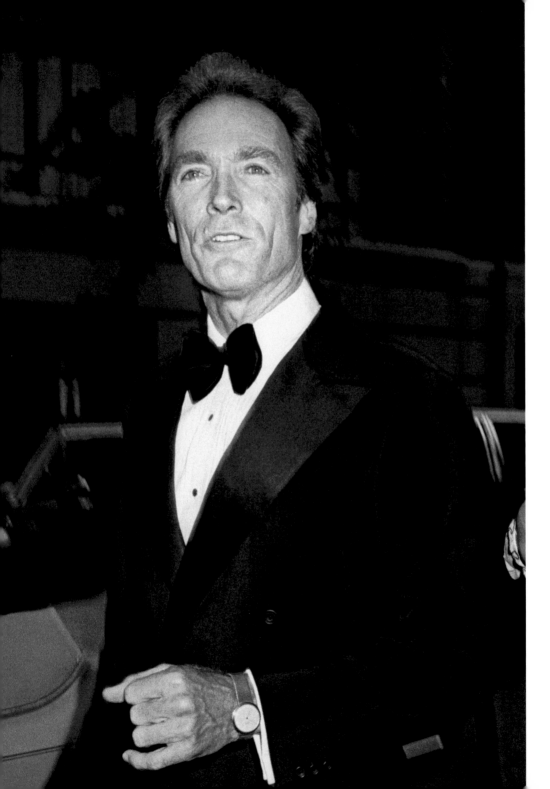

June 14, 1982: Clint Eastwood at "Firefox" pre-cocktail
party at the home of Blanchette Rockefeller at 1 Beekman
Place in Manhattan. Clint is producer/director of the
flick and also stars in it as Mitchell Gant. It tells the
tale of a lone American traveling deep into the Soviet
Union in an attempt to steal high-flying Russian super-
craft. After purloining the plane, he runs into a group
of Russian Aces, and some of the most exciting dogfights in
screen history take place. The opening will benefit the
Film Preservation Fund of the Museum of Modern Art. Clint
designated the Film Preservation as the premiere's beneficiary
after he was honored at the Museum more than a year ago
and learned of the crucial need for restoration and preser-
vation of historical films in the Museum's renowned Film
Archives.

March 19, 1974: "Two of rock's all time greats, the late John Lennon and Rolling Stone's" Mick Jagger at the AFI Salute to James Cagney at the Century Plaza Hotel in California. John's former secretary and lover, has just completed a book on her

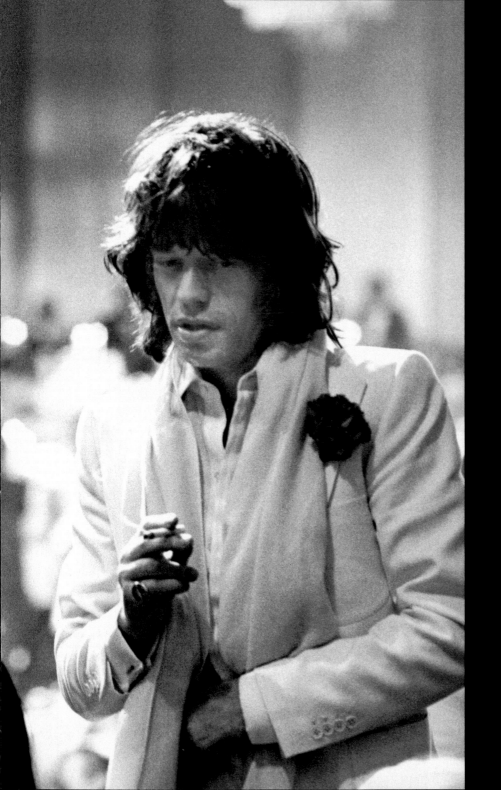

life with John titled "Loving John", which is being published by Warner Books and excerpts of the book can be read in the July issues of US MaGaZINE. The most revealing fact from the book is that May was urged to date John, by John's wife, Yoko Ono.

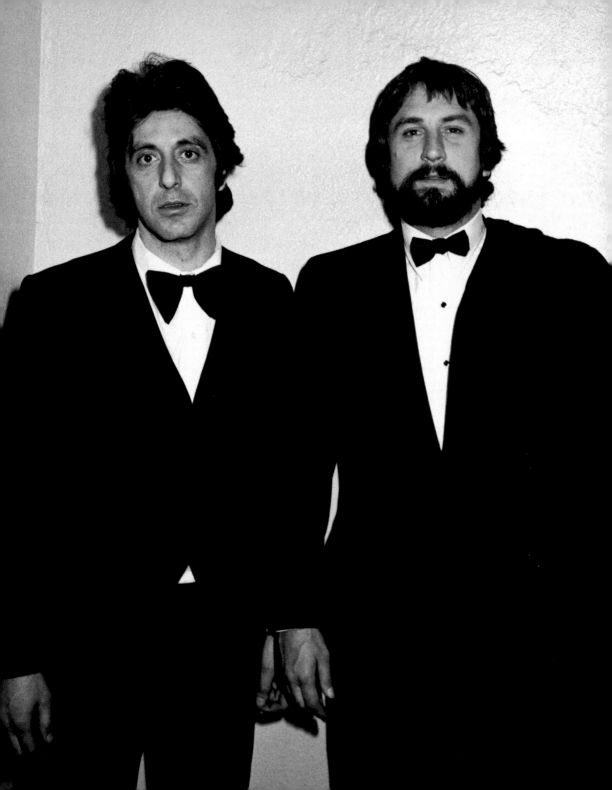

Feb. 14, 1982: In order to get this posed picture of Al
Pacino & Robert DeNiro together, I had to ask each individually
for it & then had to follow them as they left with Liz Taylor.
DeNiro said, "Don't spoil it!" Ron replied, "Just give me the
one picture of the two of you together." So they held it for
one shot & then Ron left them alone. "Night of 100 Stars"
benefiting the Actors Fund of America at Radio City Music Hall.
This photo gala supper ball at the Hilton.

Nov. 5, 1980: DeNiro & Al Pacino were taken out with heavy security through the kitchen frieght elevators of the Waldorf, after attending "The 1st Annual Actors Studio Awards" honoring Lee Strasberg. All the paparazzi were trying to get Al's attention, yelling "Al, Al, Al". Then he mimicked, "Al, Al, Al".

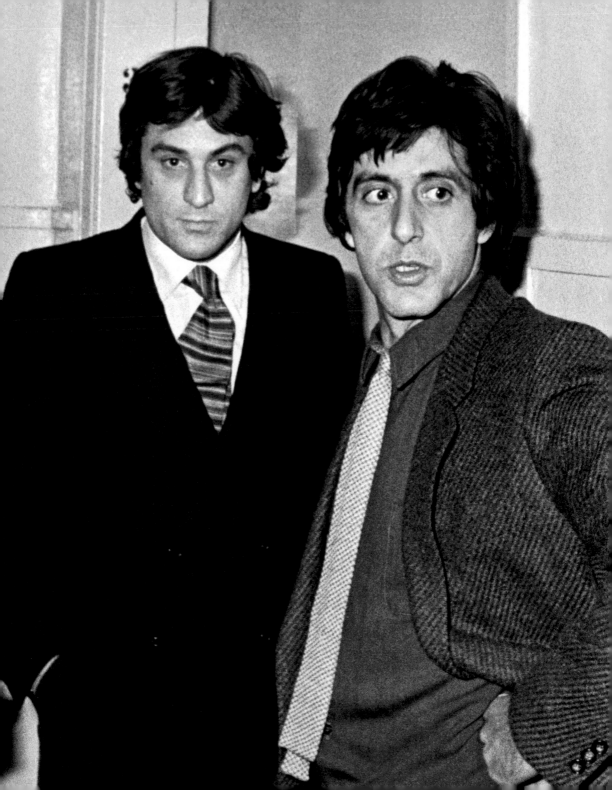

Jan. 31, 1978:
Jack Nicholson at
the Lily Tomlin
opening in
"Appearing Nightly"
at the Runtington
Hartford Theatre
in Hollywood,
California.

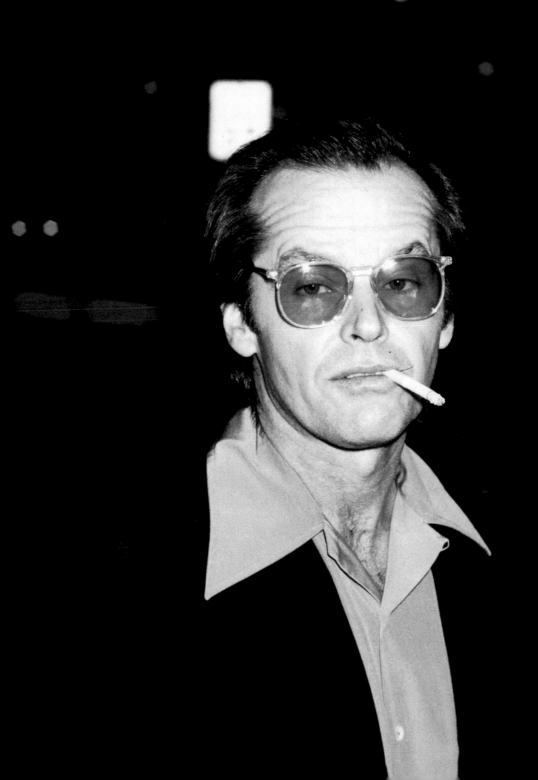

August 14, 1982: Grim faces must be the rage among the truly chic this summer, because photographer Ron Galella had little success in coaxing smiles out of this group in a rigid police-like lineup ... maybe it's Reaganomics! Snapped backstage following a concert in the Meadowlands in New Jersey were Blondie rock group members Chris Stein, the lead guitarist, Deborah Harry who is Chris's best friend and lover and lead singer and celebrity pop artist extrordinaire, Andy Wharol. Currently in the middle of their national tour, Blondie performed numbers from their new album, "The Hunter" which is a concept album based on the theme of searching, hunting or pursuing one's own Mt. Everest. Andy Warhol was on hand for the concert and came backstage later to snap his own pictures of the famous pop artists who formed the band in 1975.

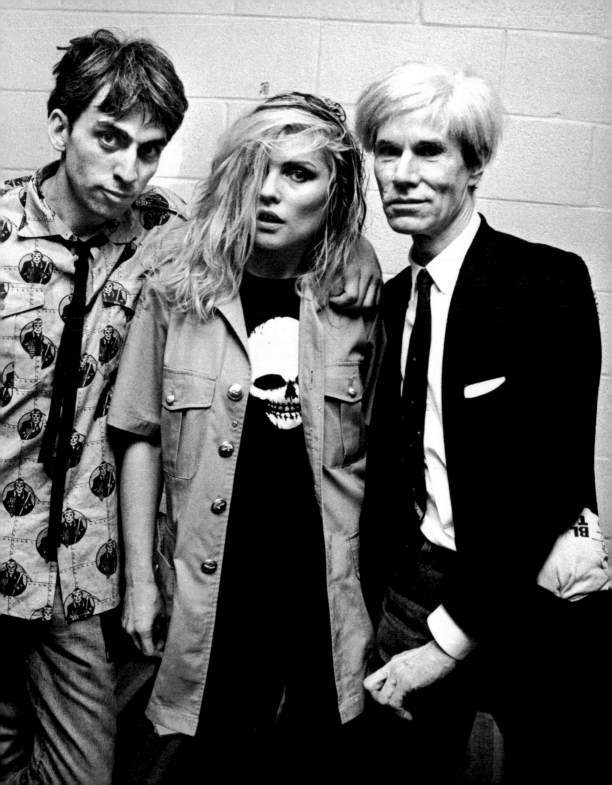

March 29, 1976:
Angie Dickinson
at the 48th annual
Academy Awards in
Los Angeles.

June 22, 1978:
Kate Herrington with
Truman Capote
at a Martha Graham
benefit at Studio 54
in New York City.
Capote was wearing a
wrap around black
coat, plus slippers
with his initials
and a wide brimmed
hat. Underneath
his coat he was
wearing a shirt and
jockey shorts.

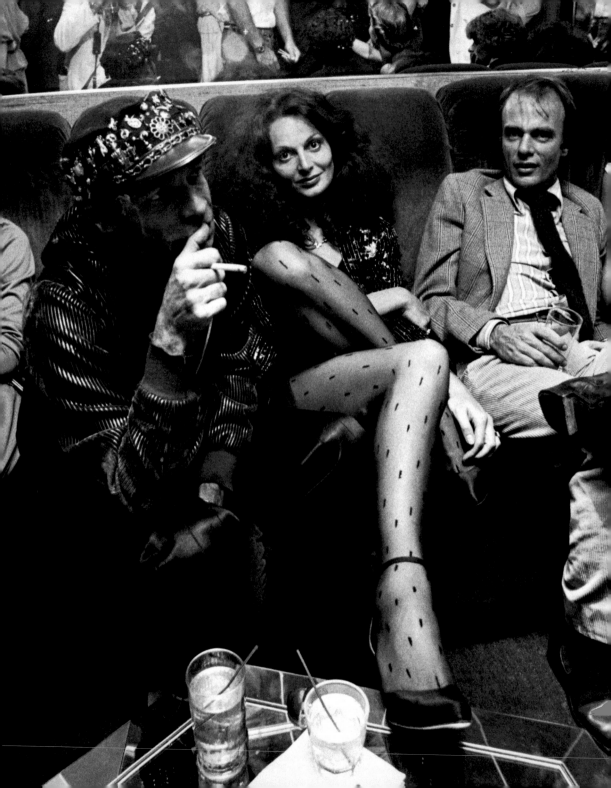

Sept. 25, 1978: Diane Von Furstenburg and Ara Gallant
at Egon Von Furstenberg's book party "The Power Look"
at N.Y. N.Y.

Oct. 4, 1982: Attention all ladies!!
Mick Jagger is auditioning for his new
film "Kalki," and Val Perrine seems
to have him all tied up! Not really,
this is what happened. Mick, Cornelia
Guest (New York Society's premiere
debutante of 1982) and Lester Persky
had dinner at Regines. Val Perrine
was also having dinner there but not
with the above mentioned. After dinner
"Mr. Rockin Roller" and "The Deb" de-
cided to go to Xenon for a little fun!
So, Persky, Mick, Ms. Guest gave Val
Perrine a ride to Xenon in Persky's
Rolls Royce.

Now we all know that the Stones tour
is over and that completion of the
film of the tour is over which is
titled "Time is on Our Side" and this
finally gives Mick a chance to work
on Gore Vidal's "Kalki" which he
purchased sometime ago. So maybe, just
maybe, Mick is looking for female leads
for his new film with Persky as possible
producer. But when Mick left Xenon he
was driven to the Carlyle Hotel in
Howard Steins limo and Ms Guest left in
a cab. When Mick arrived at the Carlyle
Hotel's elevator? It was no other than
guess who was waiting for him at the
"Ms. Deb" herself who recently quoted
in "People" Magazine, Oct. 11, 1982
"You've got to be outgoing to be a deb,
Well Cornelia, I guess that explains it
Meanwhile, Micks girlfreind/model, the
beautiful Jerri Hall is in Europe
modeling.

October 12, 1971: Transvestites, including Candy Darling and Holly Woodlawn, at

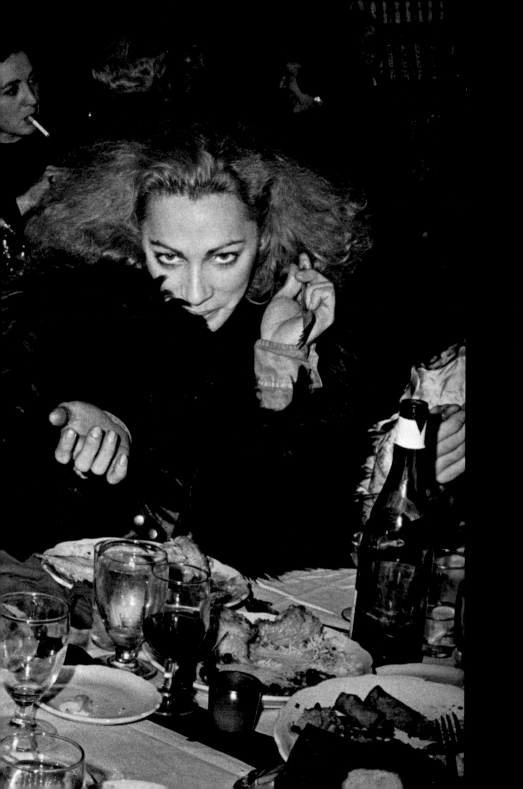

the premiere party of Jesus Christ Superstar held at the Tavern on the Green.

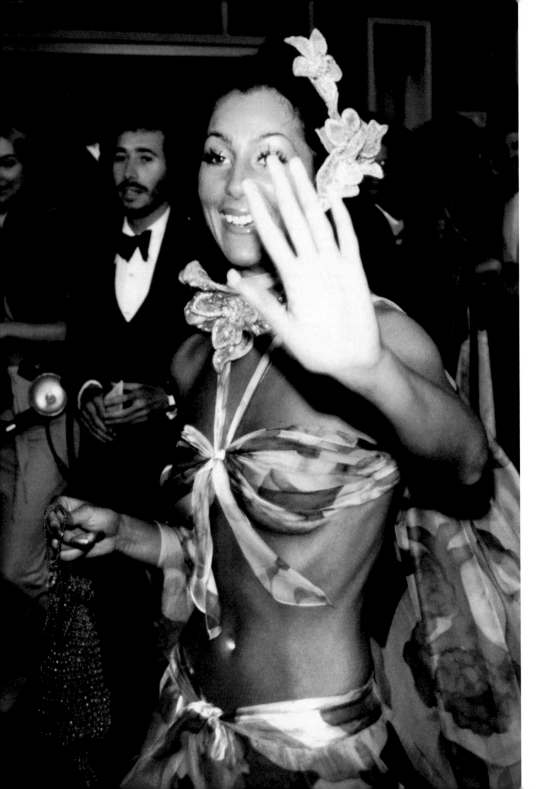

April 2, 1974:
Cher greets
Ron Galella
at the 46th Annual
Academy Awards.

May 4, 1985: Stunning Diana Ross was all smiles when she was snapped at The Apollo Theater in New York City. She was one of the many musical celebrities who performed during a gala 50th Anniversary taping at The Apollo Theater. Many musicians got their professional start at the club in Harlem.

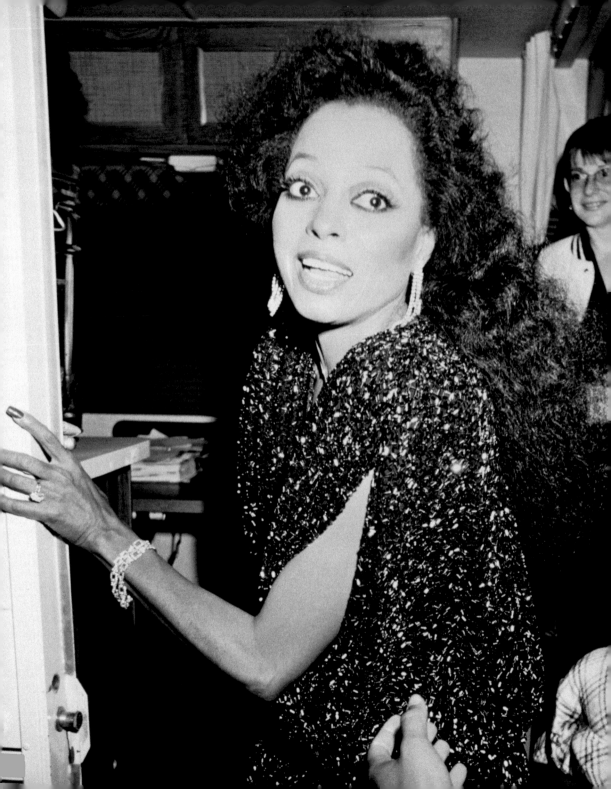

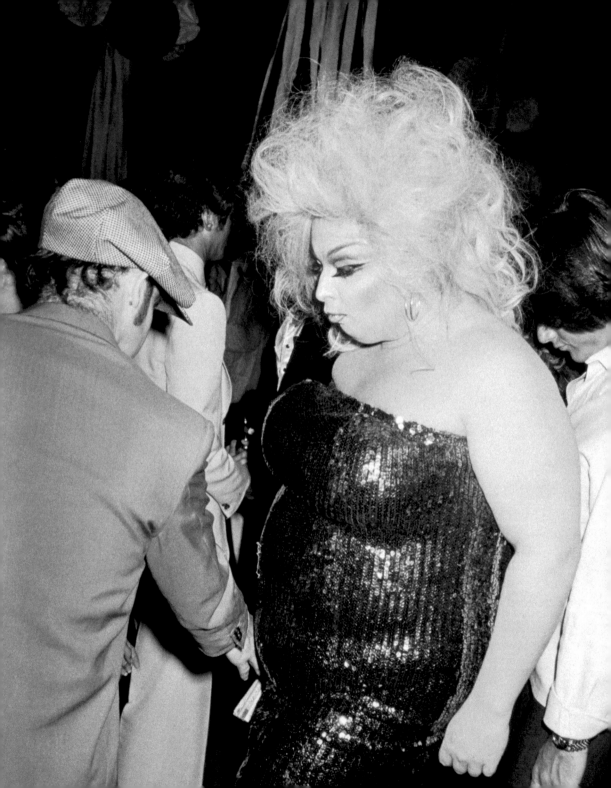

June 13, 1978: "Are those things really real?" quipped rock superstar Elton John to the outrageous Divine. Elton certainly had his hands full when he bumped into the underground and camp star Divine at Studio 54 in New York City. They were among the many celebrities who attended the premiere and party for the hit film, "Grease".
PHOTO CREDIT: RON GALELLA

Campy Divine is dead

By PATRICIA O'HAIRE
Daily News Staff Writer 3/8/88

Divine, 42, the campy, outrageous 300-pound transvestite star of such underground films as "Pink Flamingos," "Polyester" and "Hairspray," died yesterday in Los Angeles.

Divine, whose real name was Harris Glenn Milstead, apparently was the victim of asphyxiation, but his family was awaiting a full report from the coroner's office, said Peter Hass, publicist for the recently released "Hairspray."

Divine was in Los Angeles to film an episode of "Married With Children," a TV series, in which he was to have a man's

role. That was a bit out of character for him; usually he appeared as a raucous, bizarre-looking, foul-mouthed woman.

He affected gross female makeup, eyebrows arched to mid-forehead, enough eye shadow to bury a town, cupid's-bow lips, rouged cheeks, hair falls and wigs so strong and tall they could practically walk by themselves.

He starred in seven movies made by John Waters, a friend since his schooldays in Baltimore. Waters directed all but one of the films in which Divine appeared, and that was the only one in which he worked as a man, "Trouble in Mind," in 1985.

In Waters' films, his image was usually that of someone depraved, frequently psychotic. The idea was to outrage and infuriate the movie audiences, and in that they succeeded. As he once told an interviewer, "It's an image that's been hard for the American public to take close to their hearts."

Yet the films' very outlandishness gave them cult standing.

Divine, who lived in New York, frequently appeared at parties in drag, continuing the outrageous image he had patterned for himself.

He is survived by his parents, Harris and Frances Milstead, who live in Florida.

January 31, 1977:
Michael Jackson, the
young recording star and
performer, continues to
top the charts year
after year. Again this
year, he walked off with
his share of awards at
the American Music
Awards in Los Angeles,
California.

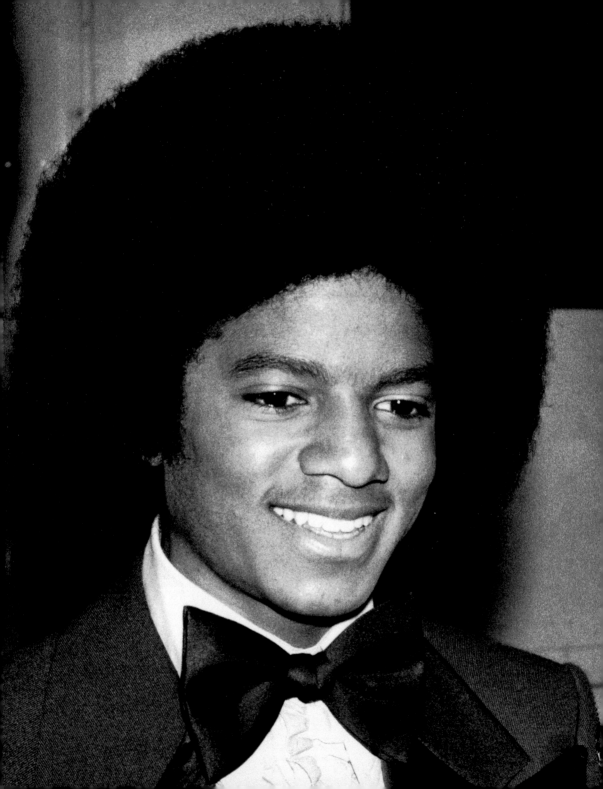

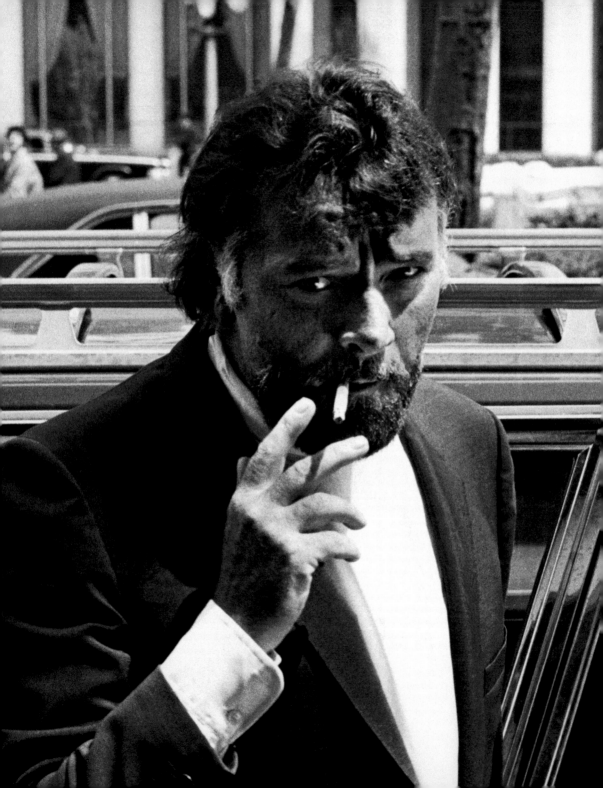

May 11, 1969: Richard Burton arriving
at the Plaza Hotel in New York City.

Ron Galella (signature)

March 27, 1981: "Rocky III" press conference L.A. Sports Arena. Sly Stallone introduces "Rocky's" newest adversary "Mister T" who will play Clubber Lang. Mister T who was born on the south of Chicago, is a boxer, bodyguard, wrestler and former football player. "Rocky III" marks his film acting debut. Mister T born Lawrence Tero.

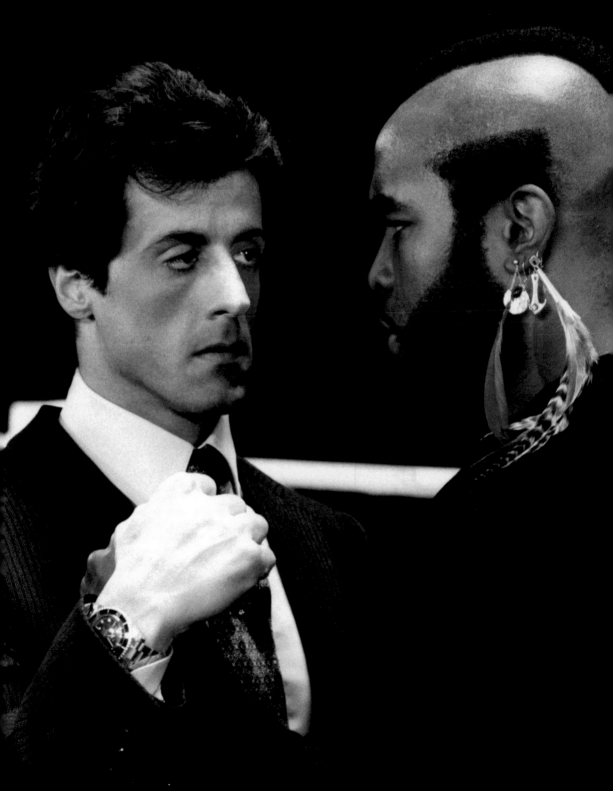

April 1, 1978:
John Belushi going
backstage to see
Keith Carradine at
the Roxy Theatre.

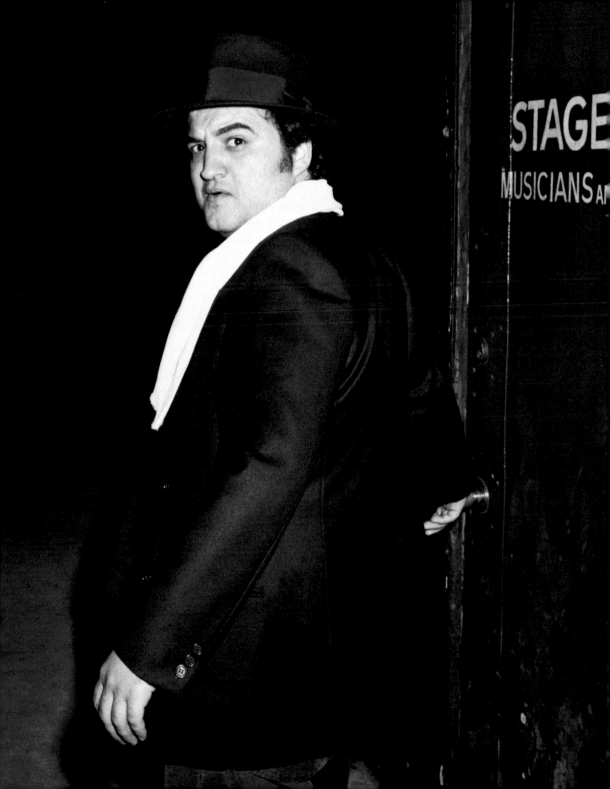

Aug. 23, 1981: Kennedy Compound,
Mass. Muscle man Arnold Schwarzenegger
gets the task of carrying the ice
chest as he walks on the pier head-
ing for a day of sailing & water
skiing.

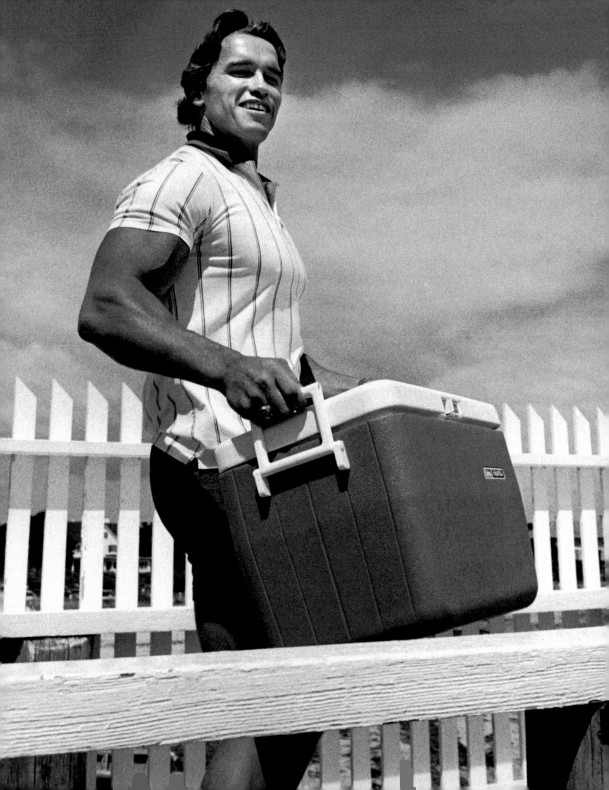

May 1968: Warren and Julie had a bungalow on Malibu Beach,
California. One day I caught Julie and a girlfriend of hers
leaving the bungalow in a sports car. They raced at high speeds
up the Pacific Coast Highway, with me following in a rented
Volkswagen; they lost me in no time. I made a U-turn and tried
looking for their car, which I finally spotted in the Malibu
Market parking lot. I ran in the market and saw Julie barefoot at
the meat counter. I got this photograph in available light so she
was unaware. When she checked out I became visible shooting a few
more. She was very shy and embarrassed. Her girlfriend pleaded
with me to leave her alone, which I did.

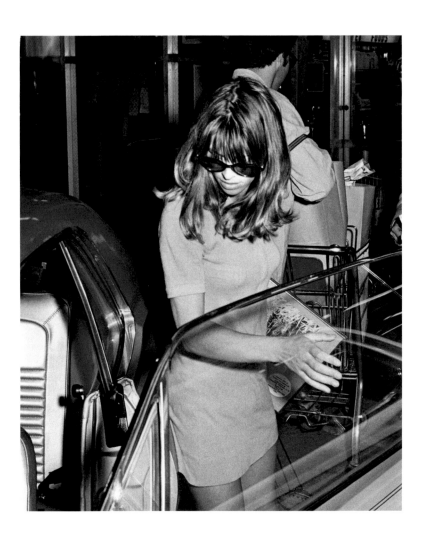

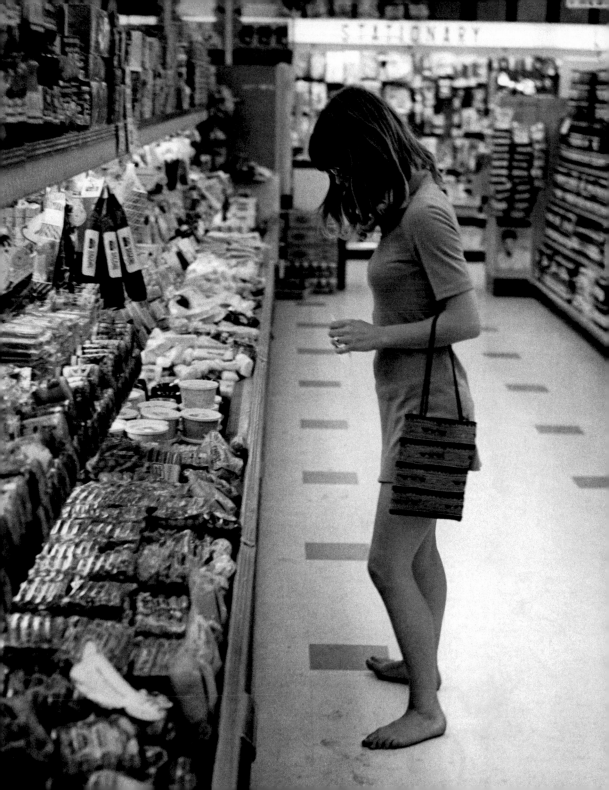

March 18, 1989:
Madonna celebrated
her recently
released "Like A
Prayer" album with a
party at the Park
Plaza Hotel in Los
Angeles, Ca. She
sported platinum
locks and was
surrounded by heavy
security at the
party hosted by
Warner Brothers. On
hand for the bash
was Madonna's
friend, comedienne
Sandra Bernhard in a
floral minidress and
her "Dick Tracy"
co-star, Warren
Beatty who kept his
head down!

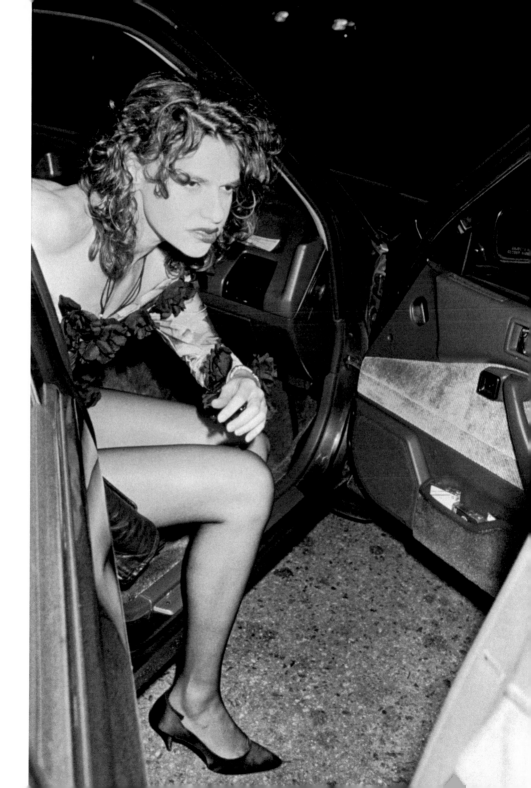

Oct. 7, 1979: Dustin Hoffman & gal Lisa Gottsegen play peek-a-boo outside Chasens.

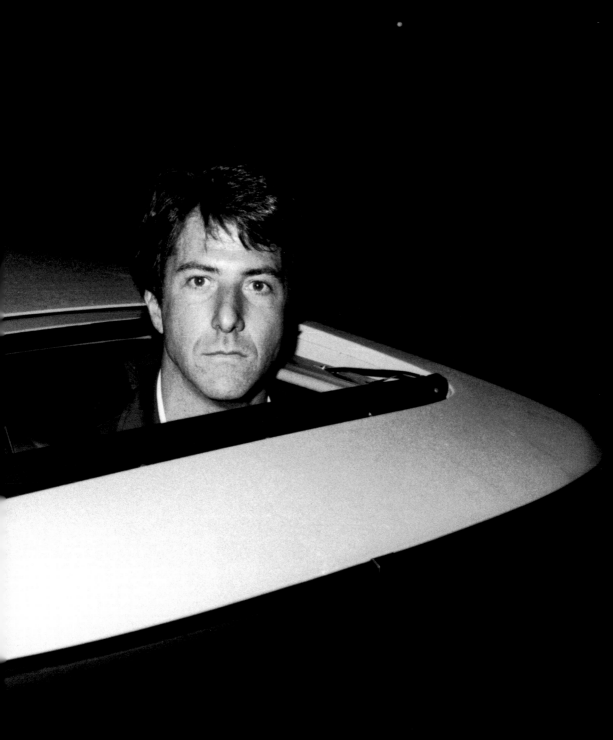

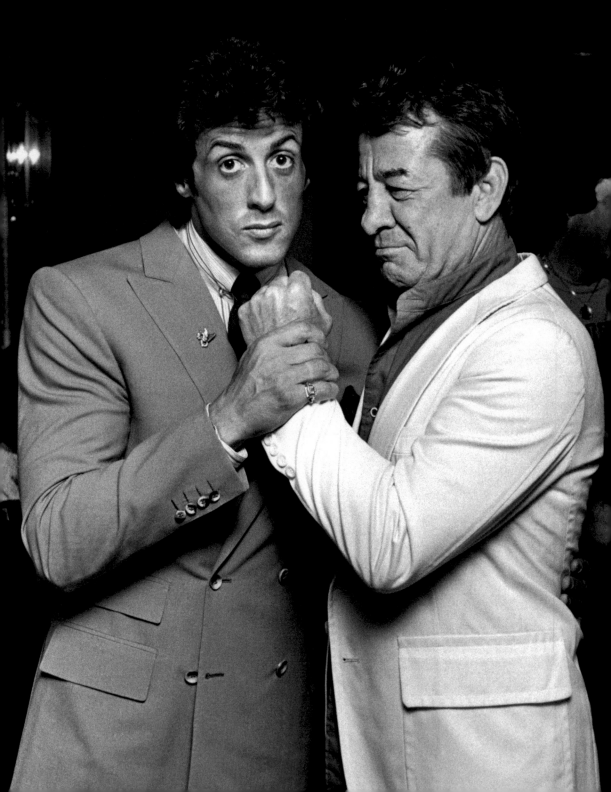

July 6, 1982: Actor/writer/director Sylvester Stallone
who conceived and played the role of Rocky Balboa in
three "Rocky" movies, finally met a real life "Rocky",
former middleweight boxing champ, Rocky Graziano. The
two put up their fists for photographers during a press
conference and weigh-in at the Tropicana Hotel/Casino
in Atlantic City. Stallone was in the seaside resort to
promote Lee Canalito, a young heavyweight boxer whose
career he is sponsoring. Stallone told reporters, "There's
a little "Rocky" in all of us" and referring to Canalito
he said, "His career is "Rocky IV". I'm living out my
fantasy through Lee." Graziano, who had a distinguished
fighting career, still maintains his interest in the sport
and is getting back into the fight business with a stable
of 12 fighters. The Tropicana is the newest and most
elegant casino on Atlantic City's famous Boardwalk, complete
with 521 guest rooms, 3 gourmet restaurants and a 48,000
square foot casino. The most expensive complex of it's
kind in the world, it was built at a cost of $330 million.

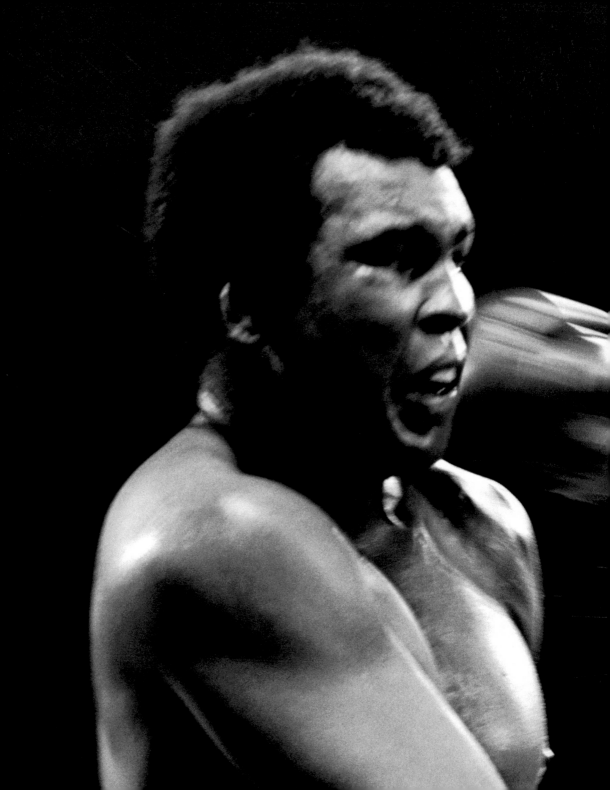

February 15, 1978:
Muhammad Ali vs Leon
Spinks fight in
Las Vegas, Nevada.

November 4, 1988: These exclusive photographs of talk show host Geraldo Rivera were taken following three hours of reconstructive nose surgery at the private office of a Manhattan doctor. Rivera's nose was badly broken by a flying chair when an outbreak of violence occured during the studio taping of a show on hate mongers. We followed him and wife Ce Ce as they stopped at a deli enroute home.

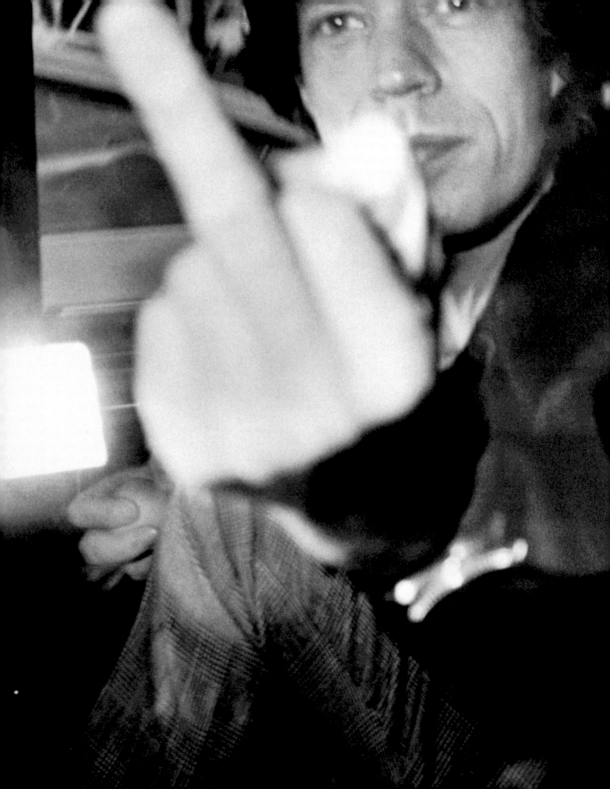

January 16, 1983: Rock n roller, Mick Jagger of the Rolling Stones flashes his famous diget at photographers who pursued him from Mizuno Gallery in Beverly Hills, California back to his hotel, the L'Ermitage. With Mick was his steady gal pal, Jerry Hall. For once Mick didn't have on his typical rock star Poster Grants! Mick and Jerry were in Los Angeles to work with Shelley Duvall in her production of "The Nightingale", a Hans Christian Anderson fairytale in which Mick Jagger plays The Emperor.

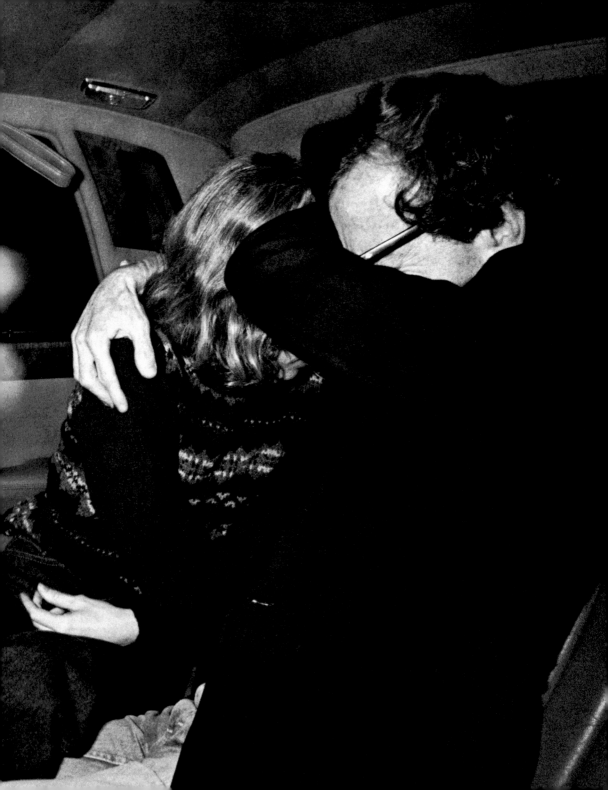

September 18, 1980: Woody Allen
shields himself and his ladylove
Mia Farrow from the flashing eye
of the camera when they were
snapped in the backseat of Woody's
Rolls Royce headed for dinner in
the Village in New York City. These
are the first exclusive photos of
Woody and Mia and confirm written
speculation that the two are indeed
together!

October 18, 1968:
Paris, France
Theatre Marigny
"Flea In Her Ear"
Premiere Elizabeth
Taylor Escorted by
Warren Beatty.
Warren and Elizabeth
were filming "The
Only game in Tolon".

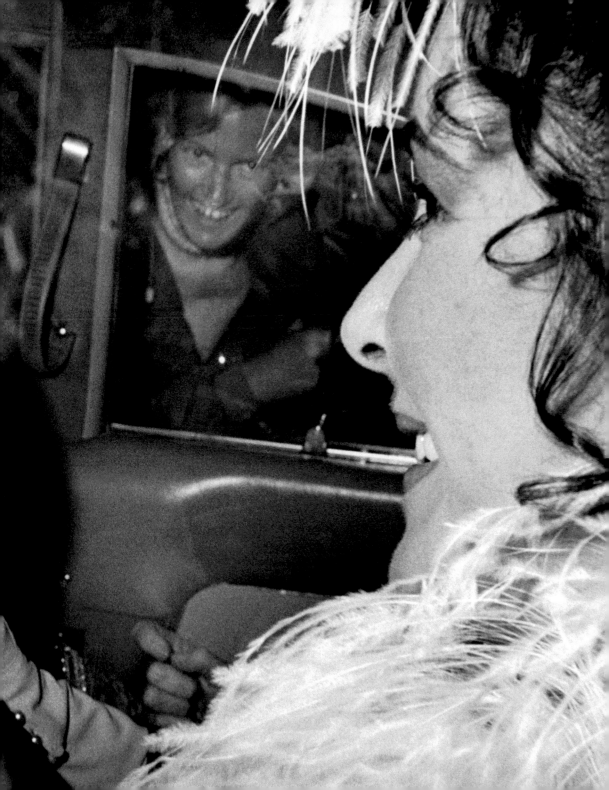

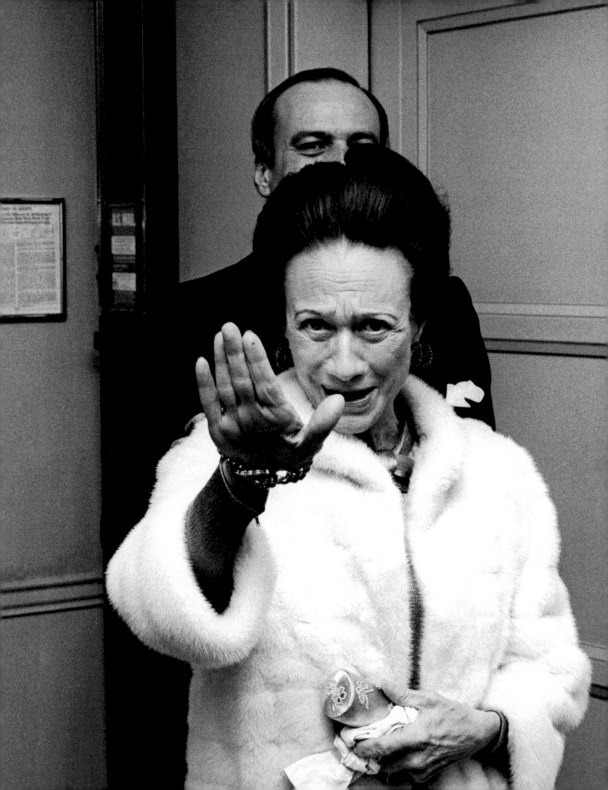

Apr. 21, 1974:
The Duchess of
Windsor at her
post ballet party
at the Waldorf
Towers Hotel.

October 5, 1972:
New York City.
A young Jack
Nicholson at the
Premiere party for
"Heat", was drooling
over young Sylvia
Miles dècolletage!

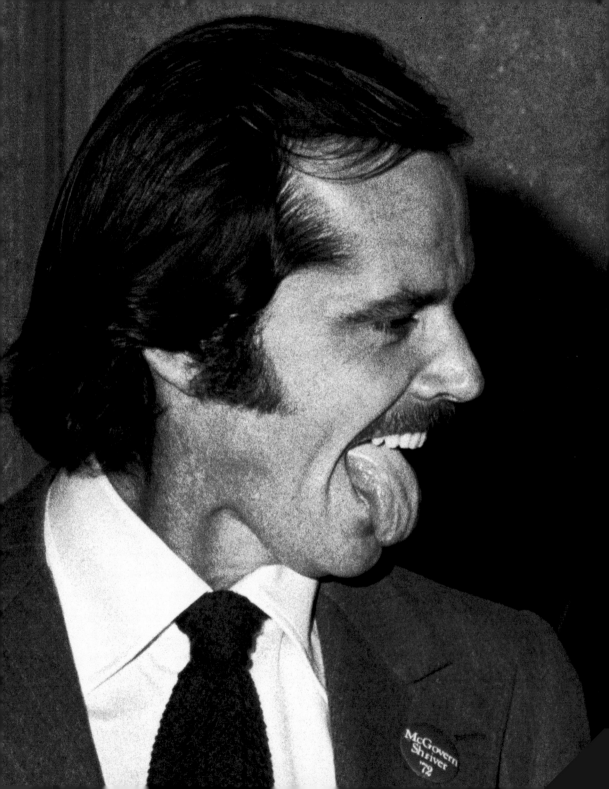

Dec. 9, 1974:
"No pictures please!"
Al Pacino at
The Understudy
Elia Kazan book
party at Lyceum.

May 6, 1969:
New York City
Barbara Streisand
arriving at Union
Carbide Gallry with
Charles Evans. Miss
Streisand prefers
her other side,
but I think she's
beautiful at
any angle!

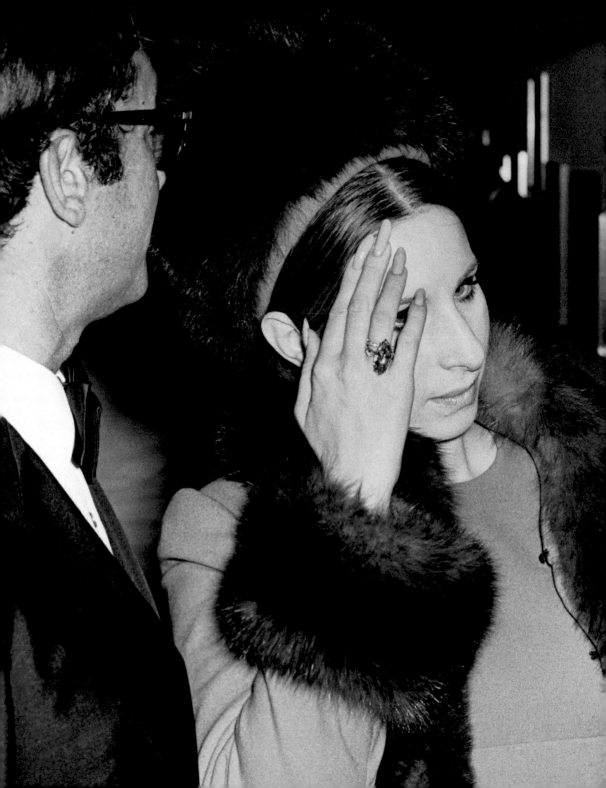

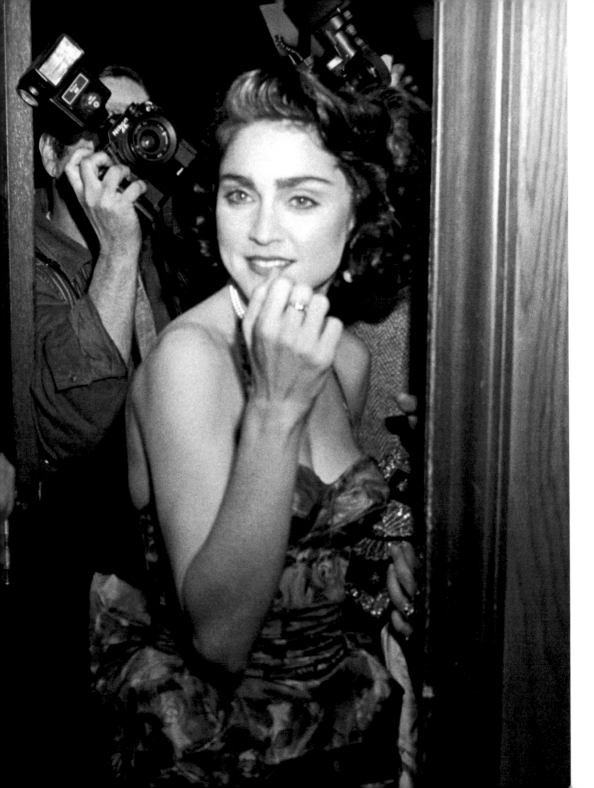

MAY 3, 1988: MADONNA opened in "Speed
The Plow", a new play by David Mamet at
the Royale Theater in New York City.
Following her Broadway debut, Madonna
celebrated with a bash at Tavern on the
Green. The "Material Girl" was mobbed
by fans and was accompanied by a bodyguard
as she departed the theater and then went
on to the party at the elegant restaurant.
Critics gave her mixed reviews.

Dec 1, 1983: Al Pacino and his current girlfriend, Kathleen Quinlan at the "Scarface" screening party at Sardi's in New York City. Pacino is currently starring on Broadway in "American Buffalo: and after his live performanc he attended the screening party for his current hit film "Scarface." Unive sal feels that "Scarface" is a poten- tial blockbuster and if it does live up to their expectations, Pacino will receive much credit for his perser- verance. It was he, who dreamed up the idea for the film, after seeing the vintage gangster epic on which it's based and convinced Universal to develop the project. The nearly three-hour film is about Miami's drug running Cuban underground. What Al wants most is to star next in the film version of K2. The show us about two mountain climbers stranded high in the Himalayas and was a moderate success as a two man play on Broad- way last season. Pacino's interest is said to have turned the project into a hot property, sparking inter- ests from other big-name actors. Meanwhile, Pacino's gal Quilan has starred in such films as "I Never Promised You a Rose Garden," "Inde- pendence Day," and "Twilight Zone: The Movie," and has been Pacino's constant constant companion for qui sometime now.

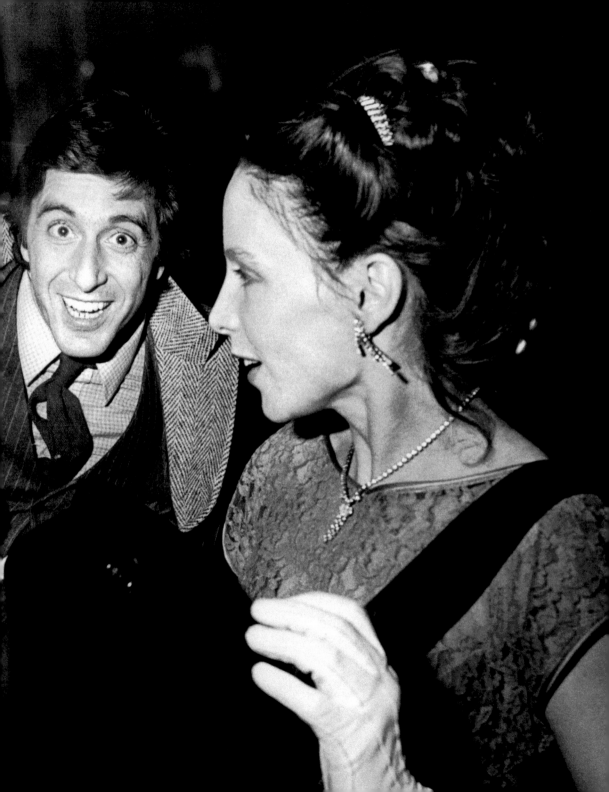

Oct 30, 1967:
Louis Armstrong
at Musician's
Relief Fund at
Roseland in N.Y.C.

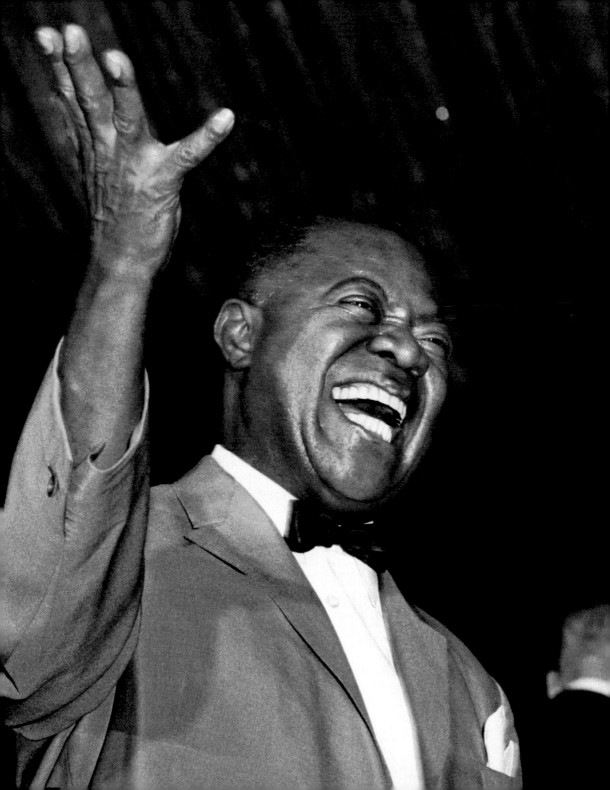

Nov. 11, 1981: Dustin Hoffman takes a walk along Central Park West. Dustin was in a very cheerful mood & told Ron & Betty jokes. Dustin asked Ron if he had any jokes to tell. RG said, "Jackie's sueing me! That's a joke!"

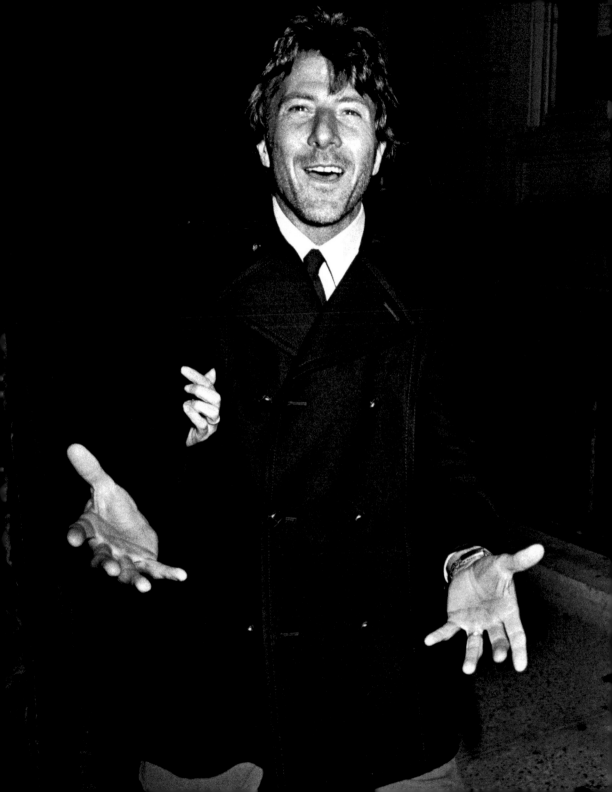

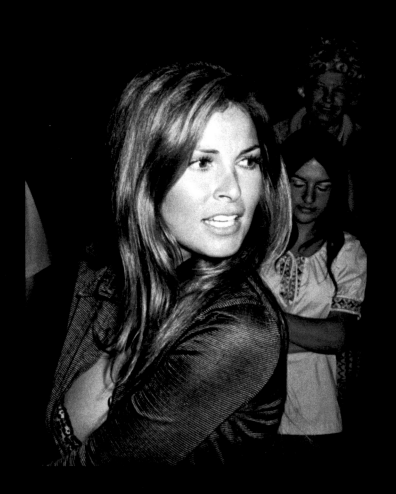

June 12, 1971:
Whoops Raquel! You
better button up!
Raquel Welch attends
Polly Bergen's party
at her home in
California. Here's a
1983 update: In April
of this year, it was
reported that Welch
would be coming back
to Broadway, but not
in "Woman of the
Year". She offered to
do it here and in
Europe but husband
Andre says Raquel will
be in a new play,
which will open first
in London and later
on Broadway. In August
it was reported that
she was asked to
return to "Woman" for
it's tour of the
country, but she
replied she doesn't
want to leave New
York or her husband.
Supposedly, Raquel is
after "Woman of the

Year" producers, Larry
Kasha and David Landay
to find a new stage
musical for her.
Next is Raquels new
health and beauty
book, which can't seem
to find a home. The
book was originally
being published by New
American Library.
The editors of NAL
say Raquel's 20 page
letter of control was
too much and that no
publisher could
possibly meet her
demands. Next the book
went to Doubleday and
editor Jackie O. And
before you knew it
the book was with-
drawn from Doubleday,
"because they got a
much better situation
else-where". Insiders
feel it's all a ploy
to inflate the price.
A new publisher was
to be announced, we're
still waiting.

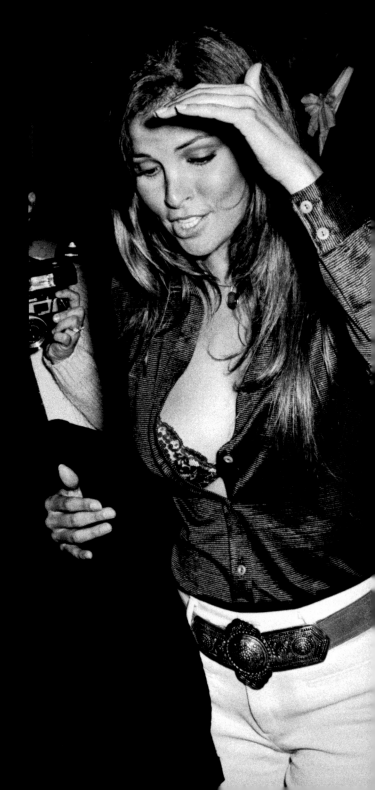

Oct. 15, 1982:
Italian superstar,
Sophia Loren arrives at the
Pierre Hotel, after
appearing at B. Altman's to
promote her new perfume,
Sophia by Coty. This is the
lovely Latin's first public
appearance in the U.S.
after being jailed in Italy
on income tax evasion
charges. Loren, will portray
Maria Callas, the Greek
diva, with Englishmen,
Ken Russell directing
the EMI/HBO production.
The film based on Arianna
Tassinopoulos' best selling
bio of the late opera star,
will be shot in Europe
starting in January.
It will give special
attention to her stormy
affair with Ari Onassis.
Ms. Loren is also
working on a film with
actor/director
Burt Reynolds.

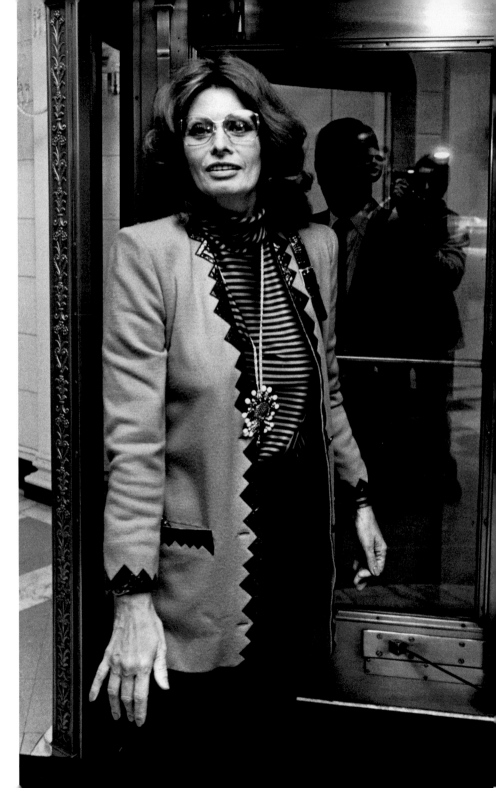

Aug 28, 1967: Twiggy at Bert Stern 's New York Studio. Twiggy, the British model and aspiring actress, born Leslie Hornby, was originally called "sticks" during her school days but was given the nickname "Twiggy" by Justin de Villeneuve (real name is Nigel Davies), her boyfriend and promoter.

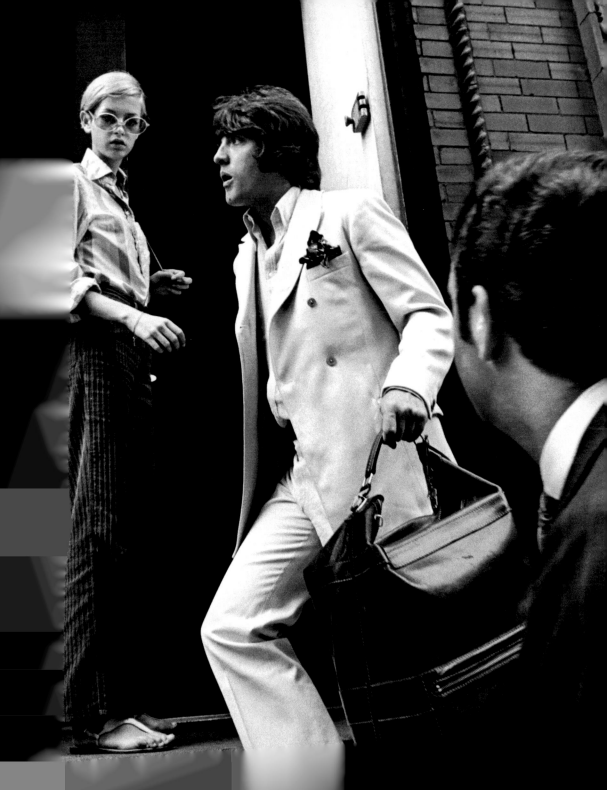

June 25, 1974:
Surrounded by his
entourage of aides
and security, Elvis
Presley departs the
Philadelphia Hilton
Hotel for a concert
at the Spectrum.
Girlfrien Linda
Thompson and Elvis
were forced to leave
through the front
because his usual
route through the
hotel kitchen was
too crowded, several
banquets were in
progress. Linda and
Elvis departed in
separate limousines.

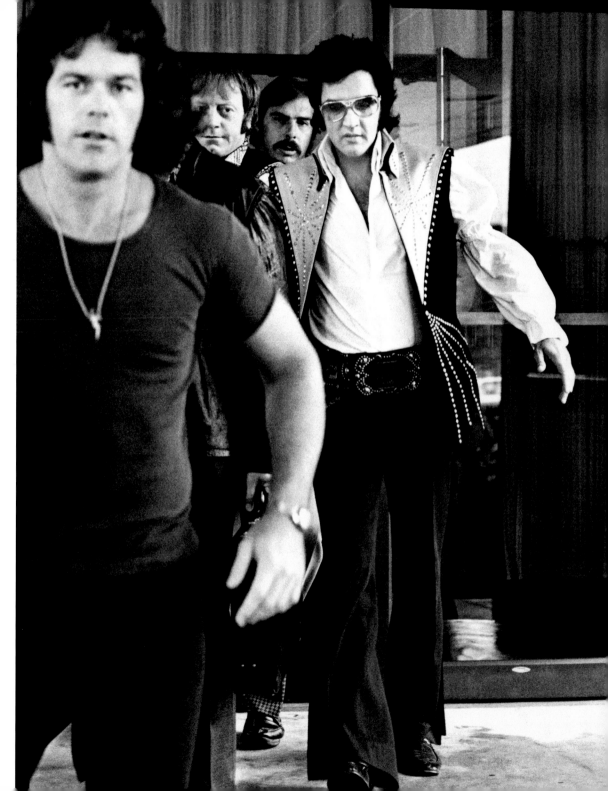

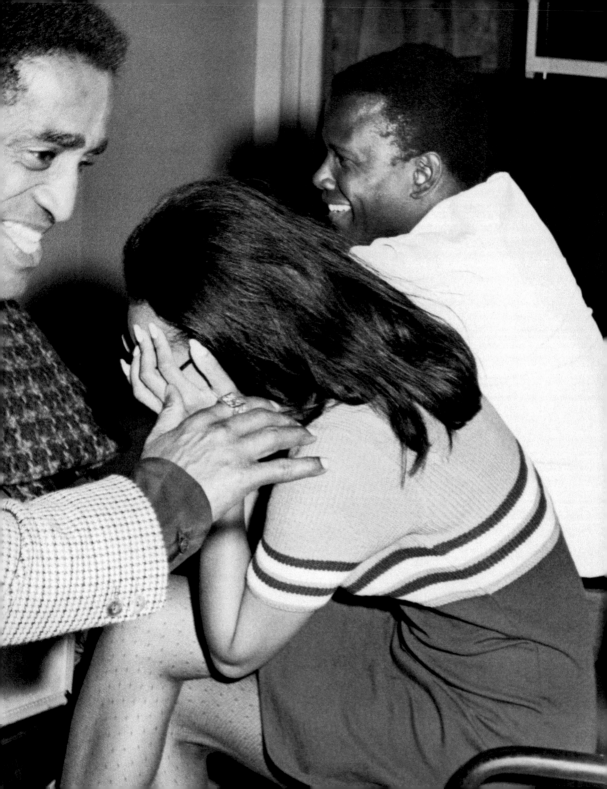

APRIL 1968 (app. 10-12): Dozens
of Hollywood celebrities flew to
Atlanta, Georgia for the funeral
services for slain Civil Rights leader,
Martin Luther King. **SAMMY DAVIS,
JR, DIAHANN CARROLL and SIDNEY POITIER**
were snapped at Los Angeles Internationa
Airport. They were waiting for their
baggage following their return from
Atlanta.

March 17, 1974:
John with his former
secretary and lover,
May Pang at "Sgt.
Pepper Lonely Hearts
Club!" opening at
the Beacon Theatre
in Manhattan. May
has just completed a
book about her life
and time with John.

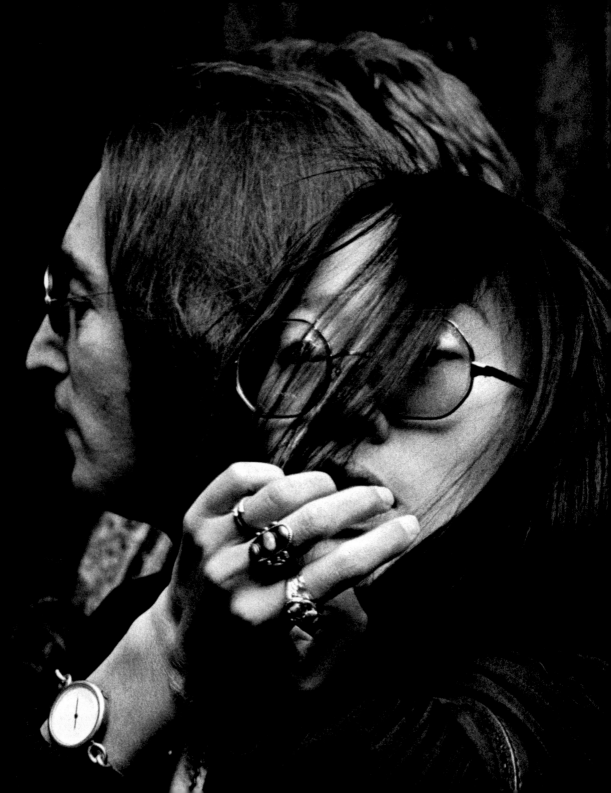

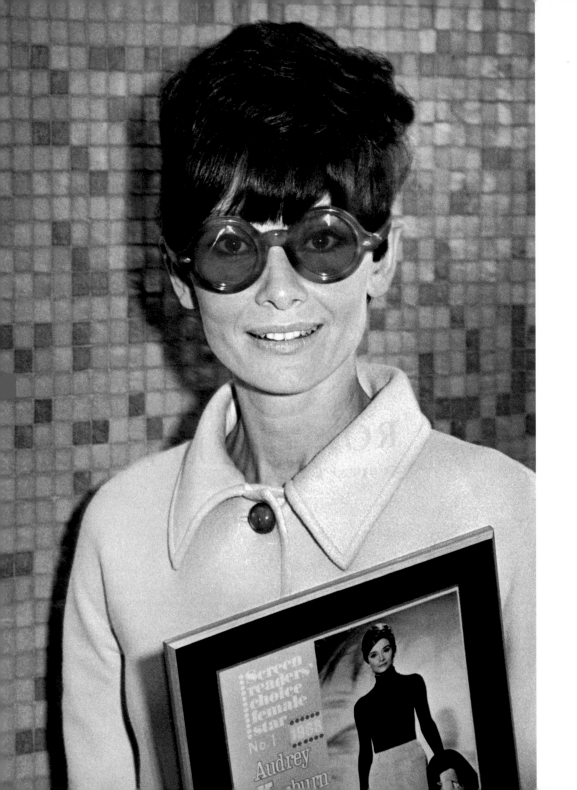

**Screen
readers'
choice
female
star ••••••
No.1 1988**

**Audrey
Hepburn**

April 1968:
Audrey Hepburn
at L. A.
International
Airport.

December 22, 1965: Dr. Zhivago, directed by David Lean produced by Carlo Ponti and starring Omar Sharif, Julie Christie, Rod Steiger, Alec Guinness, Ralph Richardson and Geraldine Chaplin premiered in New York City and was followed by a celebratory party at the Americana Hotel. Photographer Ron Galella asked SOPHIA LOREN what she found fascinating about the film's star, Omar Sharif. "His eyes!" she said making an expressive gesture. "I thought the Italians had the most beautiful eyes, now I think the Egyptians have!".

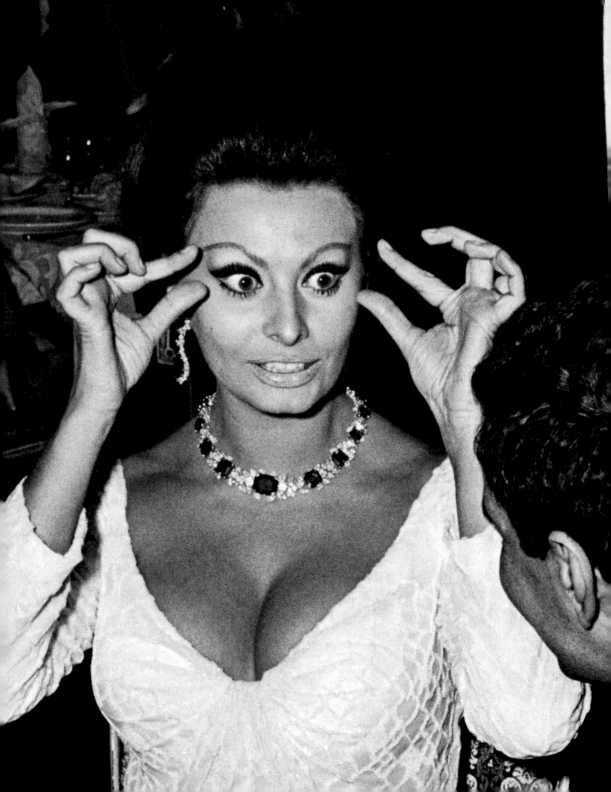

Aug. 26, 1978:
Dustin Hoffman at the 7th Annual
RFK Pro-Celebrity Tennis
Tournament in Forest Hills.
Dustin performs for Ron Galella
without being asked, all celebrities
should be like Dustin.

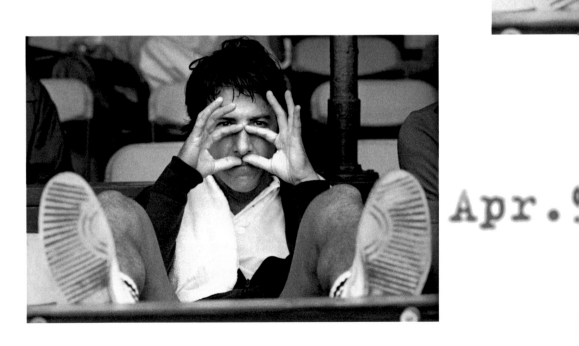

Apr.9

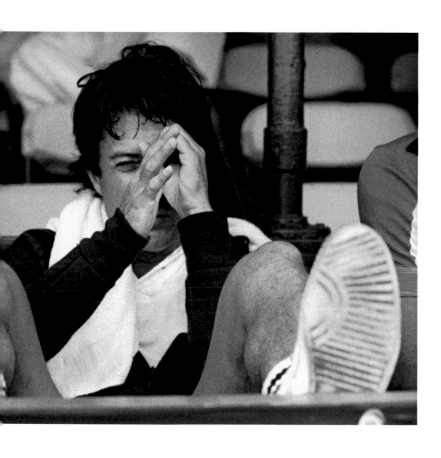

983

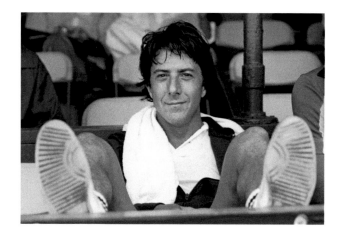

May 1, 1990:
The New York City
Ballet Spring Gala,
chaired by Ivana
Trump and Anne Bass
was held at Lincoln
Center in New York
City. Tables were
sold for $25,000
each and the benefit
evening was expected
to raise some $1
million. Ivana
Trump, the estranged
wife of Donald Trump
was escorted by
jewerly designer
Kenneth Jay Lane and
she looked
absolutely
spectacular in a
white gown, trimmed
in gold!

June 12, 1978:
Jerry Hall at
Roberta Flack party
at Xenon disco.

December 18, 1974:
Faye Dunaway at party at Four Seasons
following premiere of "The Towering Inferno".

Dec. 6, 1982: Charwoman for the evening, wearing a brown satin evening gown designed by Bill Blass, Mrs. William Buckley chats with columnist, "Suzie" at the 11th Annual Diana Vreeland Costume Exhibition at the Metropolitian Museum of Art. "La Belle Epoque" will evoke the spirit of Marcel Proust and the era he wrote of so brilliantly, the carefree years that preceded World War I.

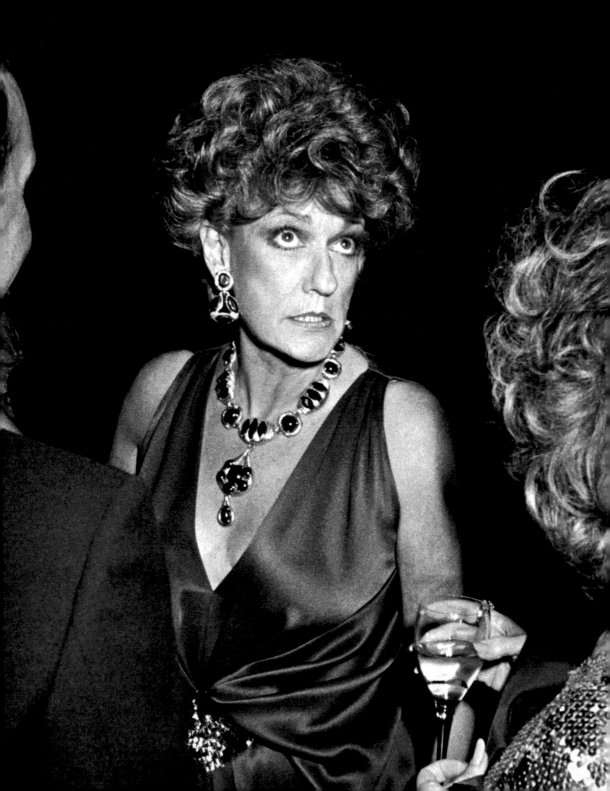

Sza Sza Gabor
at the Beverly
Hilton Hotel.

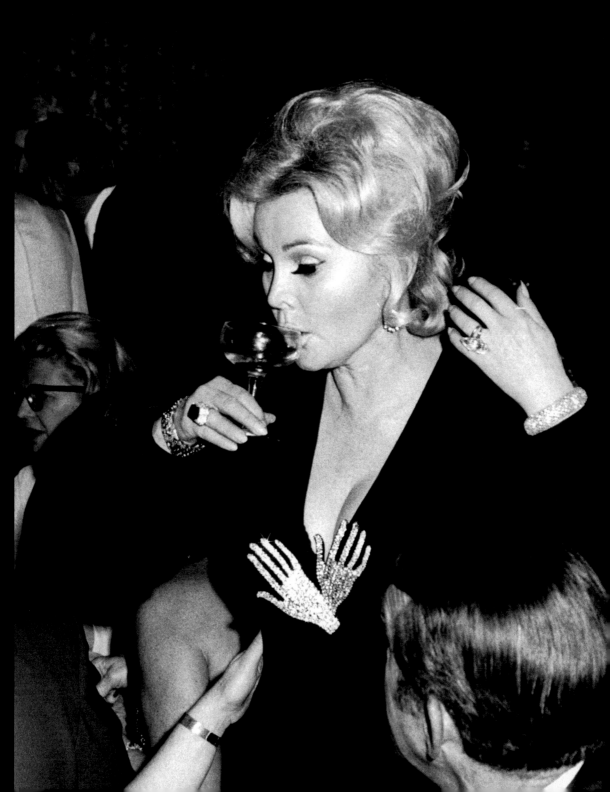

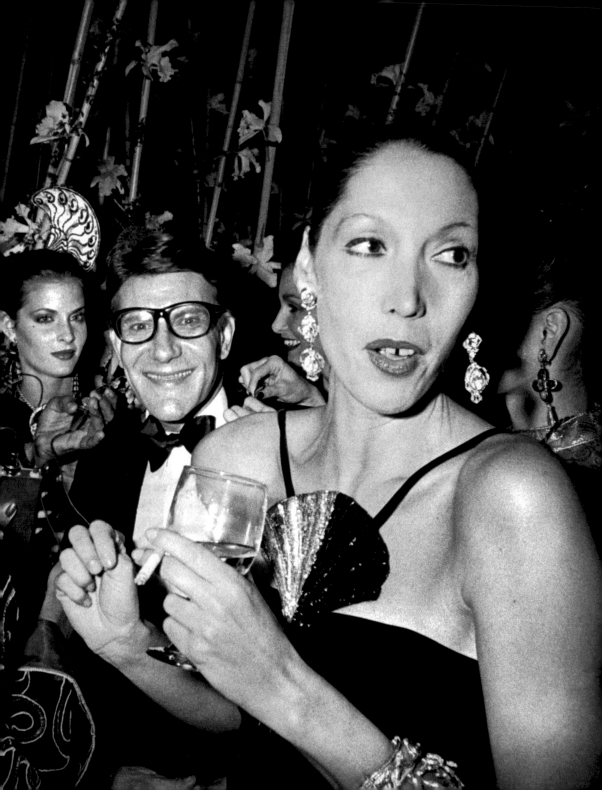

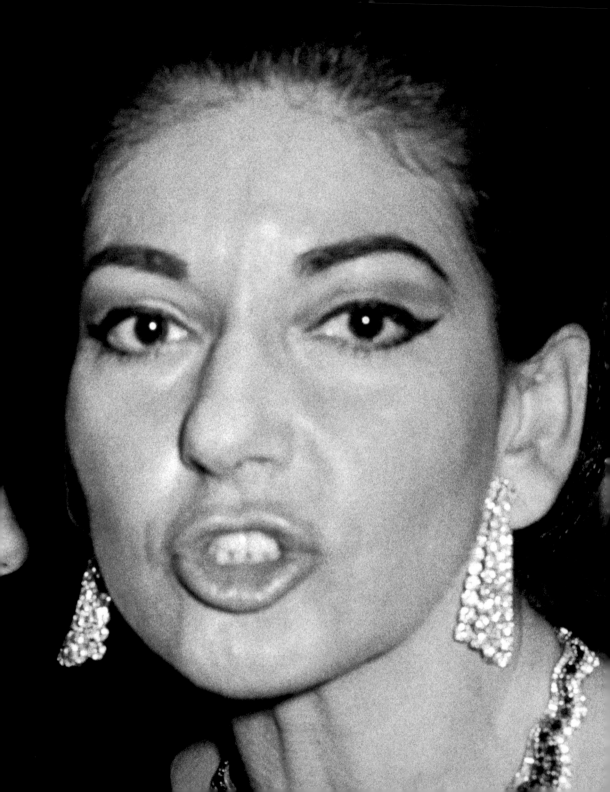

October 1968:
Maria Callas
at the Opera House
in Paris.

December 9, 1988:
Perry & Nancy Lee
Bass hosted a pre-
wedding bash at the
Metropolitan Museum
of Art in New York
City for their son,
Sid Bass and his
bride-to-be,
Mercedes Kellogg.
The creme-de-la-
creme of New York
and Texas society
donned their best
ball gowns for the
festive evening.
Real estate mogul
and billionaire
DONALD TRUMP and his
glamorous wife
IVANA TRUMP were
among the guests.

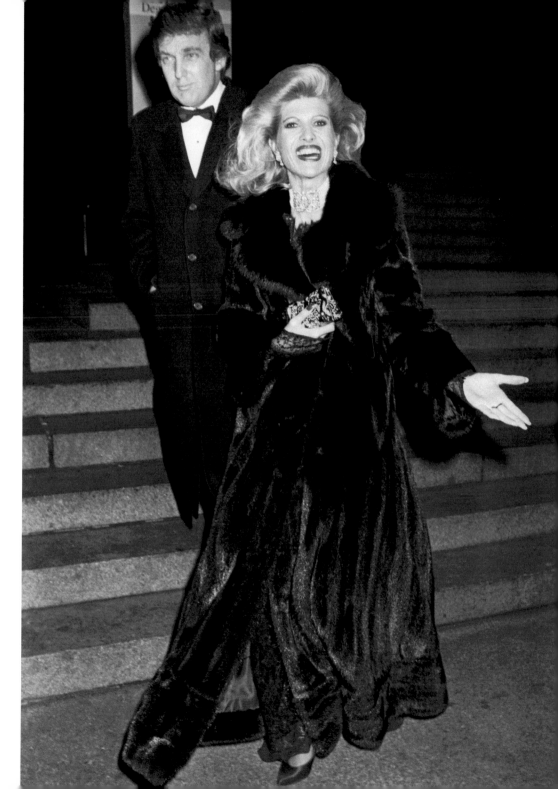

June 16, 1976:
Liz Taylor
and Halston at
Museum of Modern
Art Spring Gala.

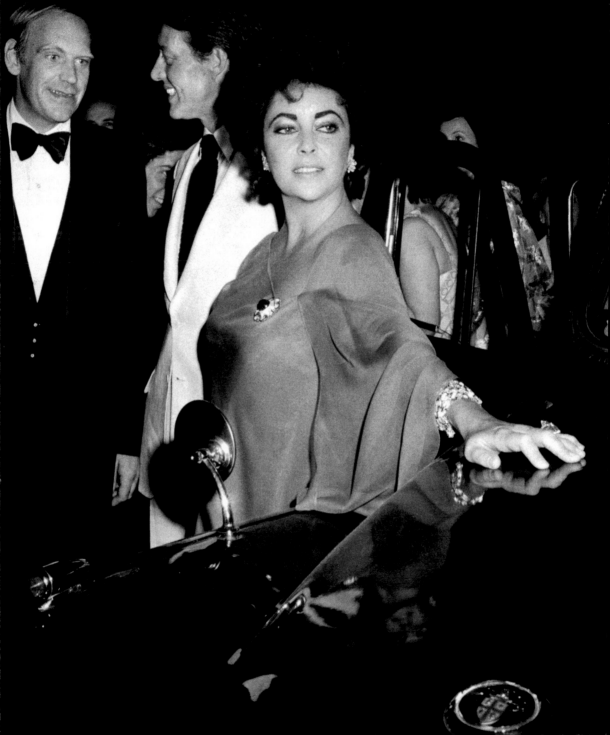

Jan 19, 1987:
Shelley Winters must
be just as surprised
as we are to see the
clean shaven-minus
pony tail, actor
Robert DeNiro!
DeNiro cleaned up
his act for director
Elia Kazan who was
honored last night
at the Waldorf
benefit for the
American Museum of
Moving Images in
NYC. Probably, if it
wasn't for Kazan
such stars as
DeNiro, Pacino and
Betty would not be
in the acting field!
DeNiro can be
seen next in
"The Untouchables."

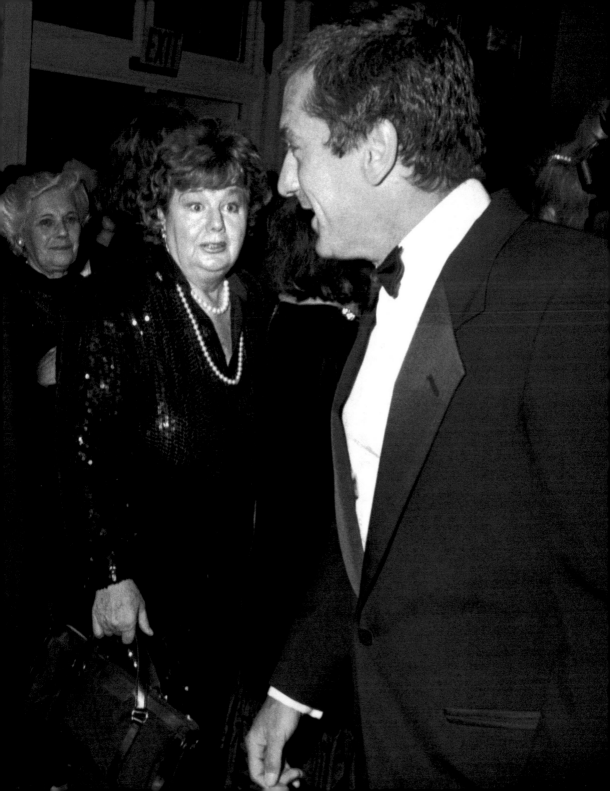

June 10, 1975: Andy Warhol chats
with his longtime associate, Fred
Hughes at the Museum of Modern Art
in New York City. They were among
the many celebrities who attended
the Annual Spring Party at the mus-
cum. February 22, 1987 update:
WARHOL DIED OF A HEART ATACK AT THE
AGE OF 58. His business manager Fred
Hughes was named executor of his
estate.

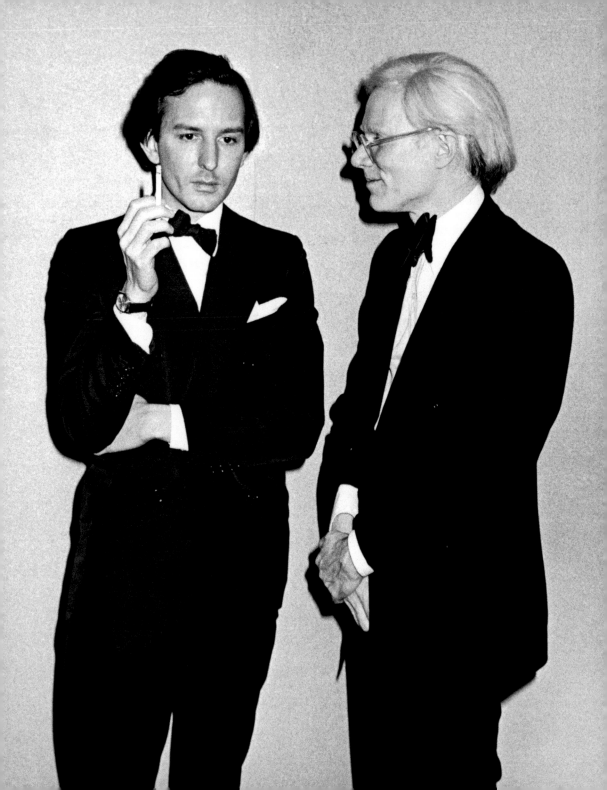

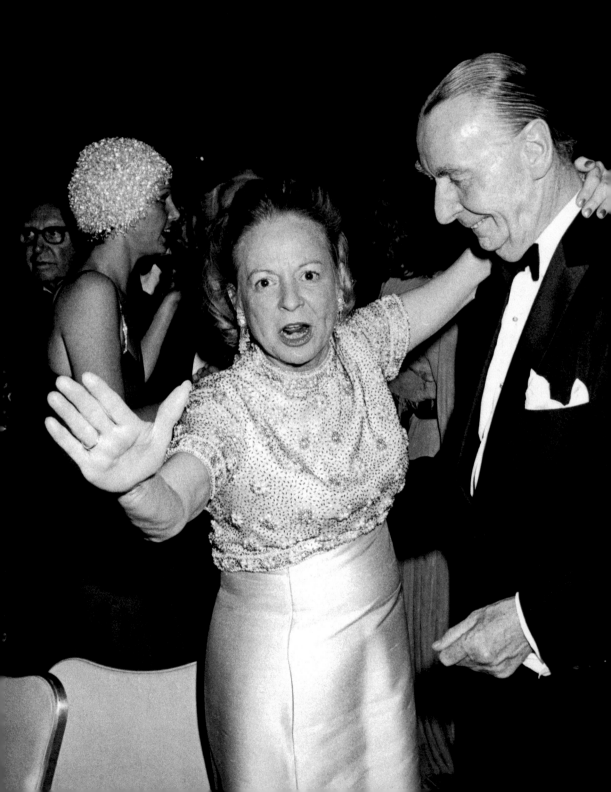

May 20, 1975: Martha Mitchell dancing at the Feather Ball Just One
Break benefit at the Plaza Hotel, playfully saying to photographer
"No Pictures."

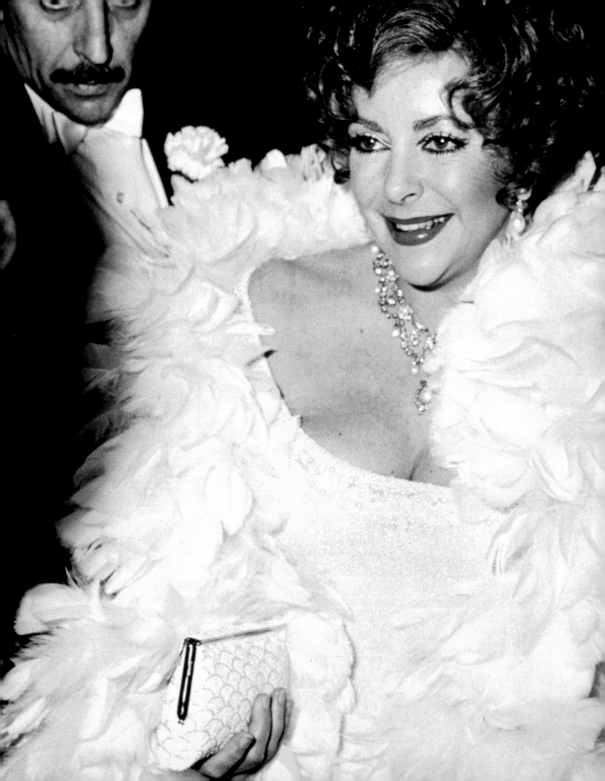

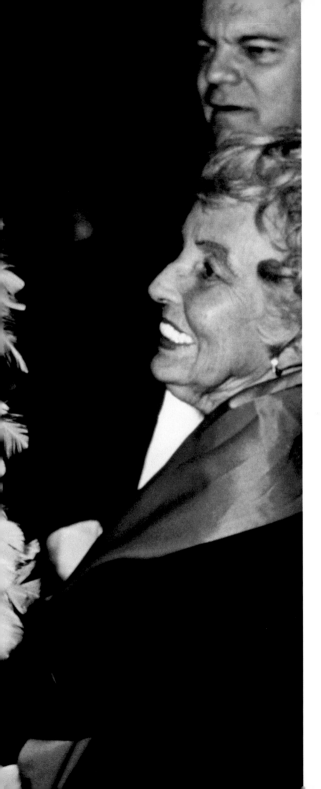

May 8, 1983:
Her Majesty, The Queen is
greeted on the Green, while
her mother Sara looks on.
The party was in honor of
the opening night performance
of "Private Lives" starring
Liz and her two times
ex-husband, Richard Burton.
Probably to avoid any
rumors, Liz and Richard
arrived separately. Liz is
sporting her own personal
diamond tiara! It was a
small private dinner party
for 1,000 and of course you
had to be dressed properly!
The city agreed to block
46th Street between
Broadway and Eighth from
5 to 9:30 pm, which they
don't even do for the real
Queen Elizabeth.
The uniformed cops and
private Dick Tracy's numbered
280-140 at the theatre and
140 at Tavern on the Green.
Liz certainly does
everything in style.
I guess she'll probably read
the unstylish review Clive
Barnes gave her and the
whole play in the 5/9/83
New York Post!

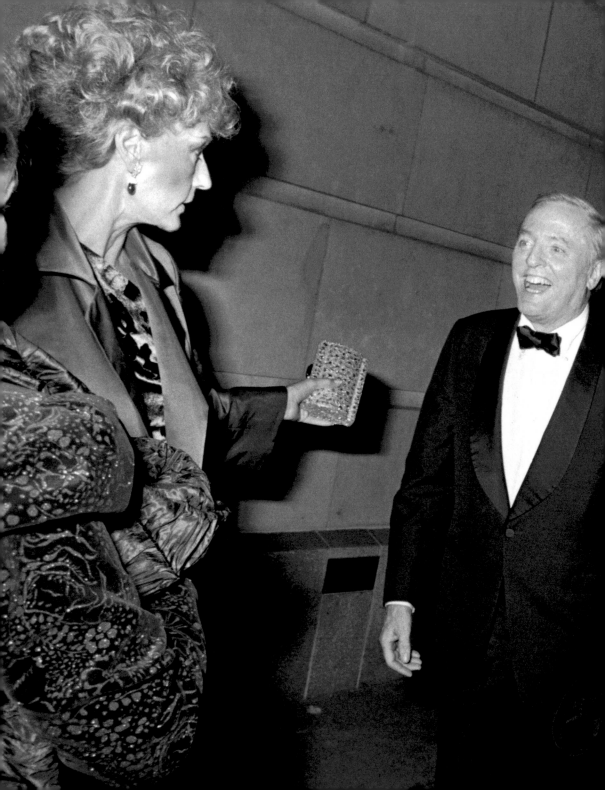

October 20, 1986:
Pat Buckley,
her husband writer
William F. Buckley
bid goodnight
to socialite and
cosmetics queen
Estee Lauder.
The group was
snapped as they
departed the
Metropolitan Museum
of Art in New York
City. They joined the
creme-de-la-creme
of society at a
party celebrating
the four month
wedding anniversary
of Barbara Walters
and Mary Adelson.
The party was a gala
sitdown dinner/dance
hosted by Ann Getty
and Brooke Astor.

May 16, 1967:
NYC Former Vice
President Richard
Nixon at the
Memorable
Eisenhower Years
Exibition at
Gallery of
Modern Art.

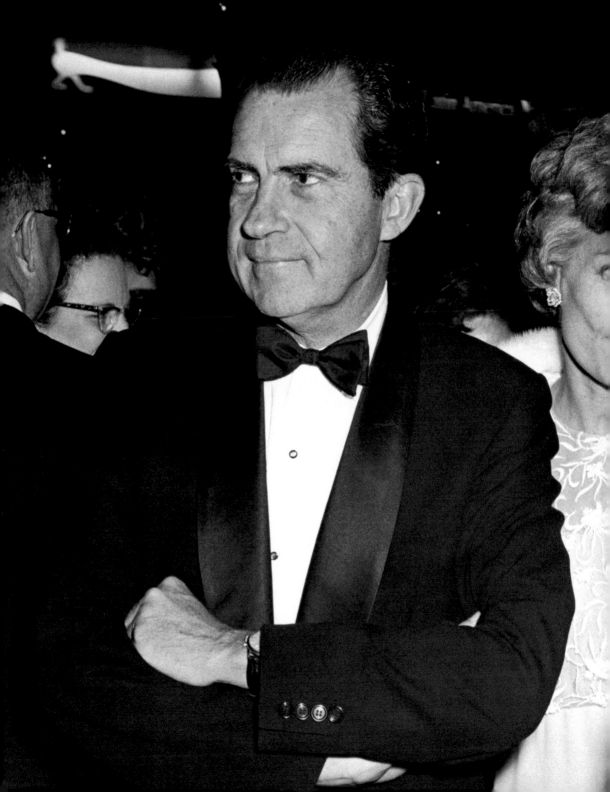

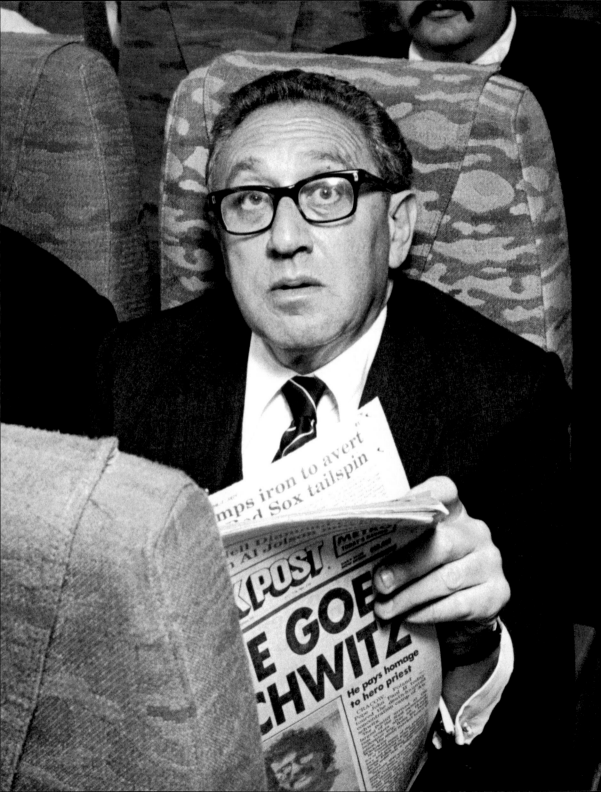

June 7, 1979:
Henry Kissinger
leaving Boston
on the Eastern
Airlines Shuttle
to NYC.

Feb. 4, 1968: Marty Allen eyeballs those rocks! remarking "Diamonds are a girl's best friend" It was at the El Morocco party after "Golden Rainbow" opened at the Schubert Theater.

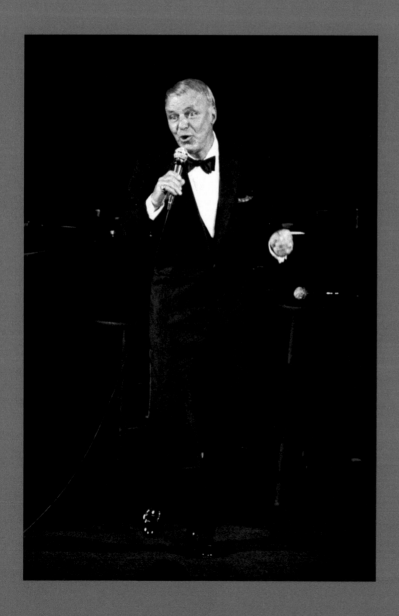

Frank Sinatra belts
out "New York, New
York" at a benefit
performance at the
Waldorf, where he
was reunited with
old Rat Pack buddy
Dean Martin. Frank
and Dean raised
$750,000 for the
dreaded eye
disease, Retinitis
Pigmentosa. The
match was arranged
by Steve Wynn,
owner of the Golden
Nuggets Casinos in
Vegas and Atlantic
City. Steve was hot
to get Frank and
Dino for this
benefit because he
just became

director of the
Retinitis
Pigmentosa
Foundation and is
one of the 400,000
Americans who
suffer from the eye
disease. Their duet
was sensational!
Martin and Sinatra
had a ball-they
toasted each other
and then did a
duet-joking all the
way. Martin told
Sinatra, "You still
got it man. You
really belt it out.
Your eyes are
popping out, but
your still
singing". Dino's 66
to Martin's 67.

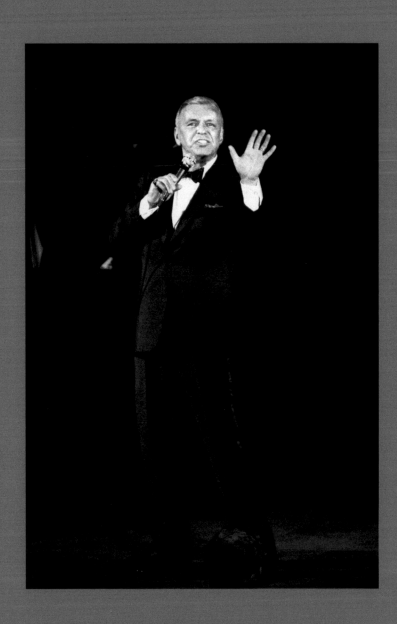

July 31, 1973:
Frank Sinatra must
think he's an angel
from heaven as I was
introduced to him
and he told me to
"Keep my distance".
Frank was awarded
the "All American
Collegiate Golf"
award at it's 9th
Annual Foundation
dinner at the
waldorf. Frank is
seen here with his
ever present
bodyguard,
Jilly Rizzo.

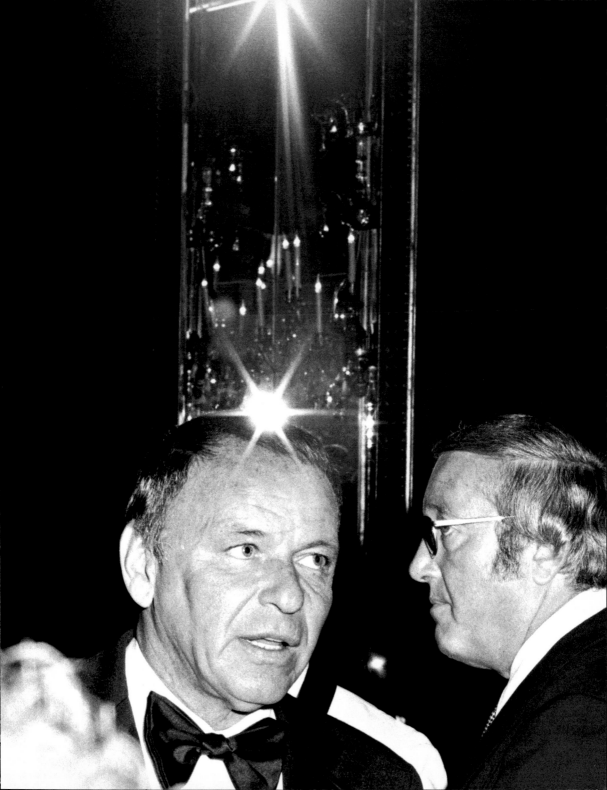

Sept 1969:
SAMMY DAVIS, Jr. was
a big hit with
London audiences
when he opened in
"Talk of the Town".
At the following
party, Sammy was
mobbed by Hollywood
friends, actress
Joanna Shrimkus and
dancer Altovise Gore
turning to check on
Sammy who she is
dating. Trendy
Sammy wore bell
bottom trousers,
Nehru shirt and his
ever-present
gold chains.

April 8, 1972: Hollywood legend and veteran film star, Charlie Chaplin received an evening of tribute at New York City's Philharmonic Hall. The star-studded evening honoring the former British silent film actor and director drew socialite Gloria Vanderbilt who is a close friend of Chaplin's current wife, Oona O'Neill Chaplin.

March 28, 1988:
Sophia Loren was at
the World Premiere
of "The Fortunate
Pilgrim", the new
NBC TV mini-series
based on a book by
Mario Puzo. The
special evening
reception and
screening was held
at Lincoln Center in
New York City.
Joining Sophia were
her husband, Carlo
Ponti and the
couple's young sons,
Carlo Ponti, Jr. and
Eduardo Ponti.
Sophia plays the
role of an Italian
immigrant who
achieves the
American Dream.

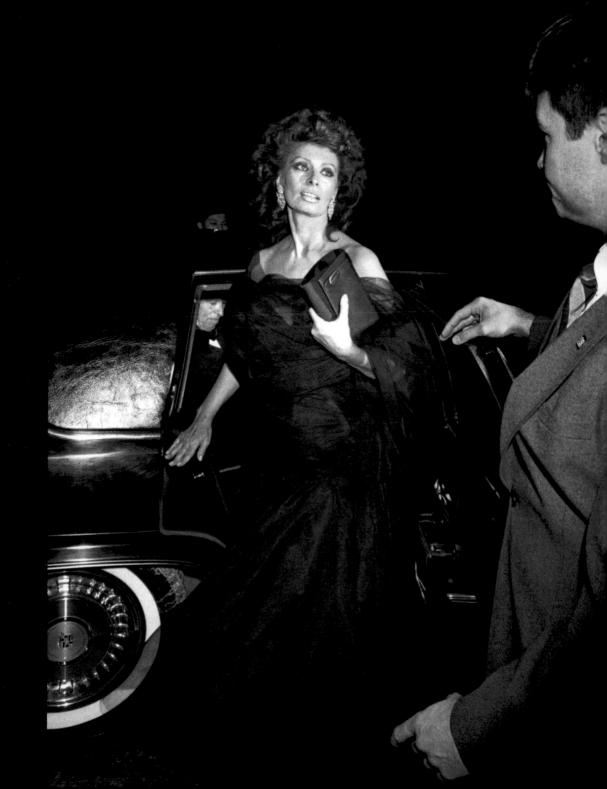

March 5, 1984: Barbra Streisand was among the firstnighters to attend the opening of the American Ballet Theater and gala party which followed at the Beverly Wilshire Hotel in Beverly Hills, Ca. Barbra was accompanied by the new man in her life Richard Cohen, the ex-husband of Tina Sinatra. But sly "Babs" and Richard managed to elude photographers by splitting during their arrival and departure.

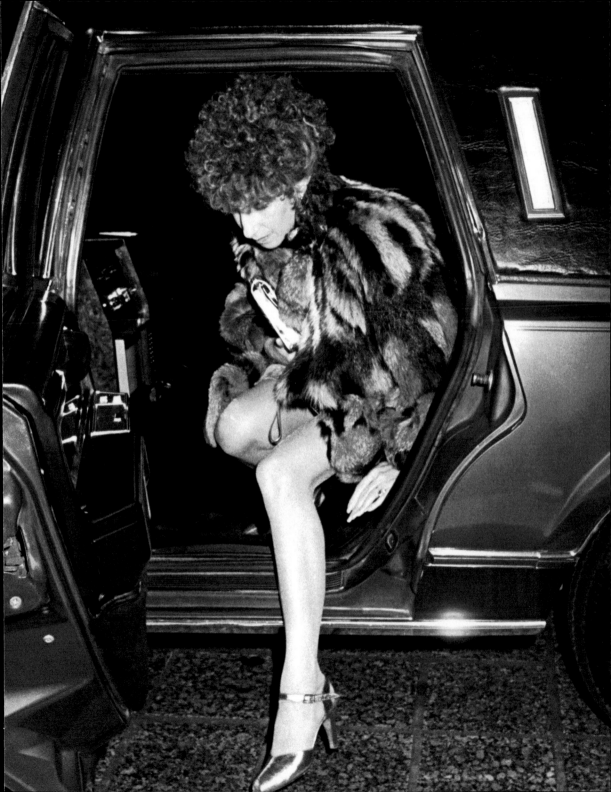

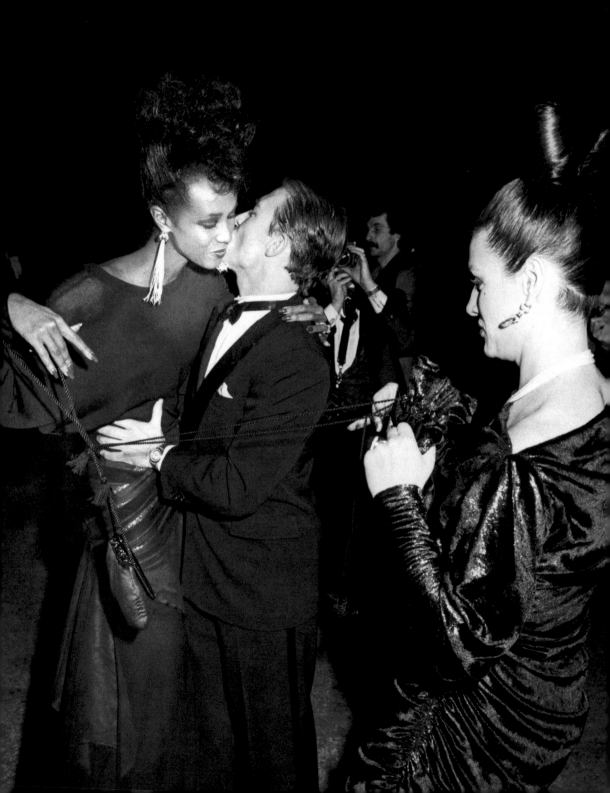

December 5, 1983: It was a comedic
tug of war between Paloma Picasso
who caught her evening bag strap in
model Iman's bag. Meanwhile, Paloma's
husband Raphael Lopez Sanchez was
locked in a tight embrace with Iman.
The glamourous threesome were decked
out in their very best for the Met-
ropolitan Museum's Annual Costume
Institute Salute to Yves Saint
Laurent, organized by the grande
dame of fashion, Diana Vreeland.
Paloma is the daughter of the late
artist, Pablo Picasso and has ex-
hibited her own talents by designing
jewerly for Tiffany's and just this
month launched a fragrance bearing
her name.

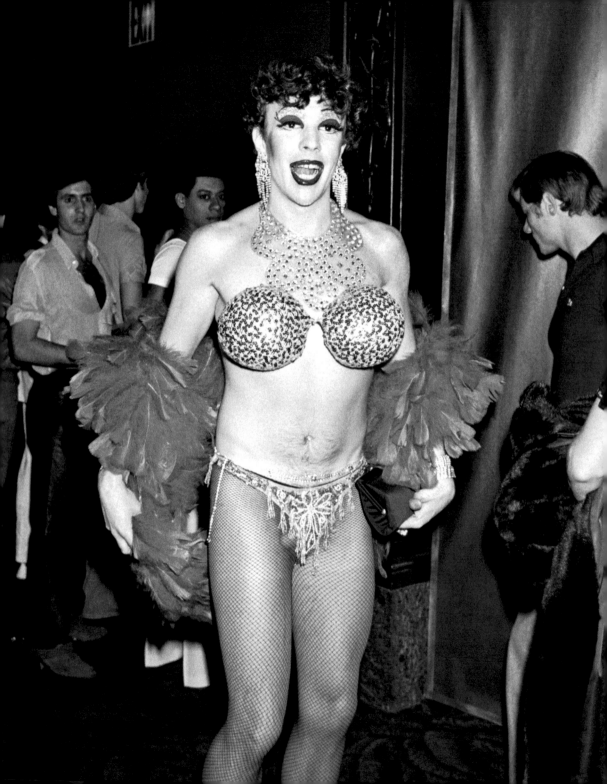

April 26, 1978:
One of the many
transvestites
at Studio 54's
First Annual
party.

May 15, 1985: Rocker/actress Grace Jones demon-
strates her power lifting ability to fellow
rockers, Boy George and Marilyn at The Palladium
in New York City. Grace was celebrating the
premiere earlier of her new film. "A View to a
Kill". Grace did her own stunts in the film and
actually lifted a man over her head!

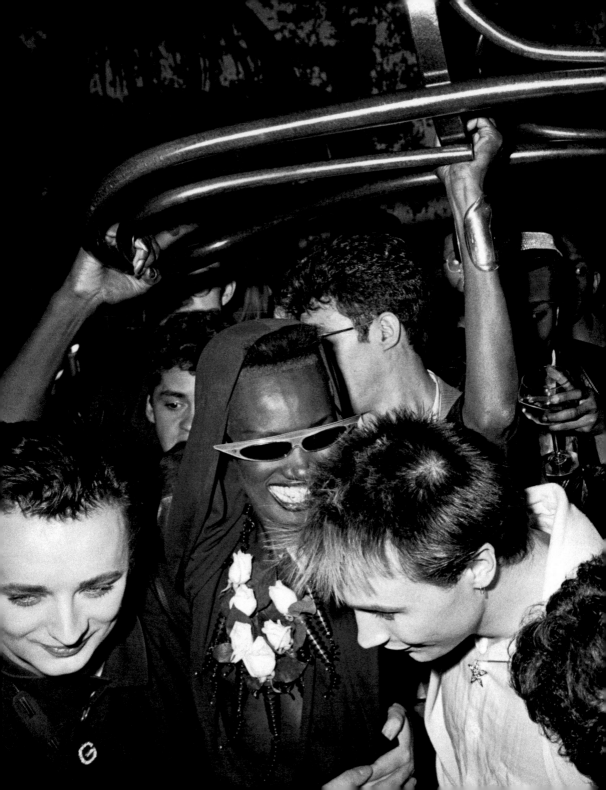

March 26, 1990:
The hottest party in
Hollywood is the one
agent Swifty Lazar
and his wife Mary
host at Spago
restaurant.
Celebrities not
attending the
Academy Awards
gather for champagne
with Swifty. Guests
included RAQUEL
WELCH, New York
nightclub diva, NELL
CAMPBELL and
standing behind
them: SHERRY
LANSING, TINA BROWN
of Vanity Fair and
fashion designer
MARY McFADDEN.

July 11, 1978:
Deborah Dangerfield
at Xenon Disco in
New York City
at "The Great
Hollywood X" party
by Le Clique.

Sept. 15, 1977:
"I could have
danced all night"
says dancer
at Studio 54's
Purple Magazine
Party.

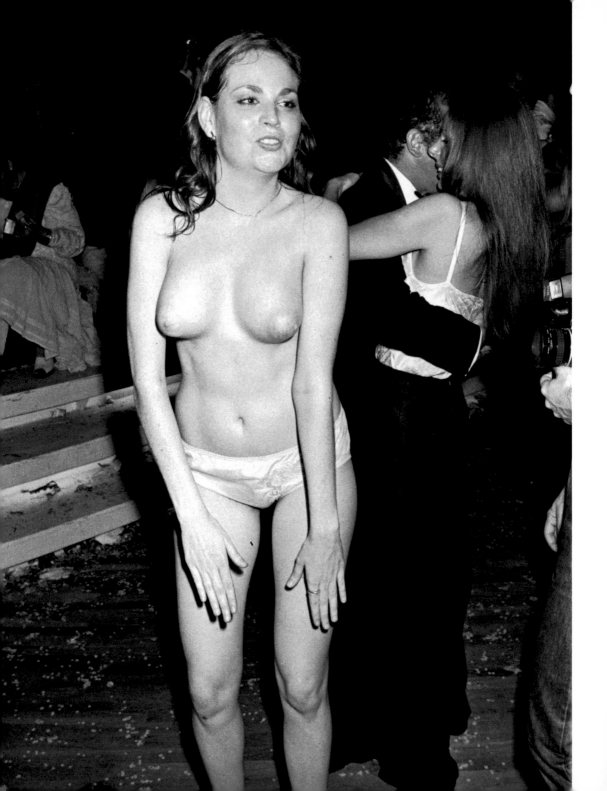

June 26, 1978; Kathleen Towers Smith- semi-nude dancer
at Xenon singles party by Jonathan Michaels.

Sept. 28, 1980:
David Bowie opens in the "The Elephant Man" on Broadway at the Booth Theatre. Here's a 1983 update on Bowie. He is a star of many faces, a supreme pop chameleon. For more than a decade, in a spectacular array of different guises, he has played the part of the outsider, becoming a rock legend in the process- David Bowie, who now, he says, is a man intent on being himself. This is the man who crashed into public wearing mascara and dresses, who declared Adolf Hitler, "one of the first rock stars"; and who officially retired after his Farewell-to-Ziggy Stardust concert in 1973. Yet now he appears almost convincingly as a normal kind of man, intent on making an "uplifting" kind of pop music. In the last three years, Bowie has made a concerted effort to escape from what he calls the "blinkered" life style of most rock stars. He lives off the beaten path in Switzerland and paints for his own pleasure. His film career began in earnest with "The Man Who Fell to Earth" in 1976. Since then he has played a Prussian stuffed tuxedo in "Just A Gigolo" (1978), a rapidly aging vampire in "The Hunger" (1983) and a tough willed prisoner of war in "Merry Christmas Mr. Lawrence". On broadway he won praise for his performance as John Merrick in "The Elephant Man" (1980). Bowie is currently on a world tour to promote his latest album "Let's Dance" and has a new lady to escort him. Her name is Jee-Ling and she is featured with Bowie on his new video disc, "China Girl".

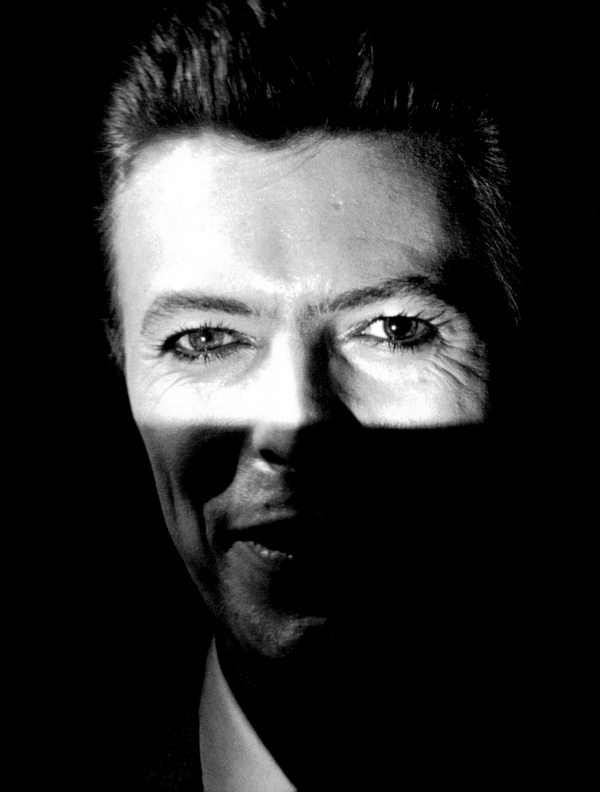

Jan. 10, 1978: Bianca Jagger dances wildy with
Sterling St. Jacques at Studio 54.

June 12, 1978:
Elton John and Caspa
(Australian model)
dancing at Roberta
Flacks: a party held
at Xenon Disco.

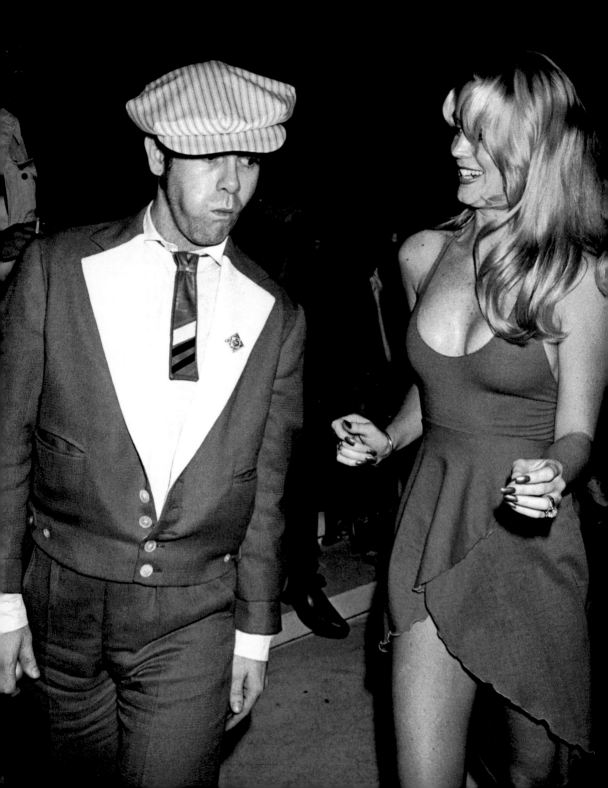

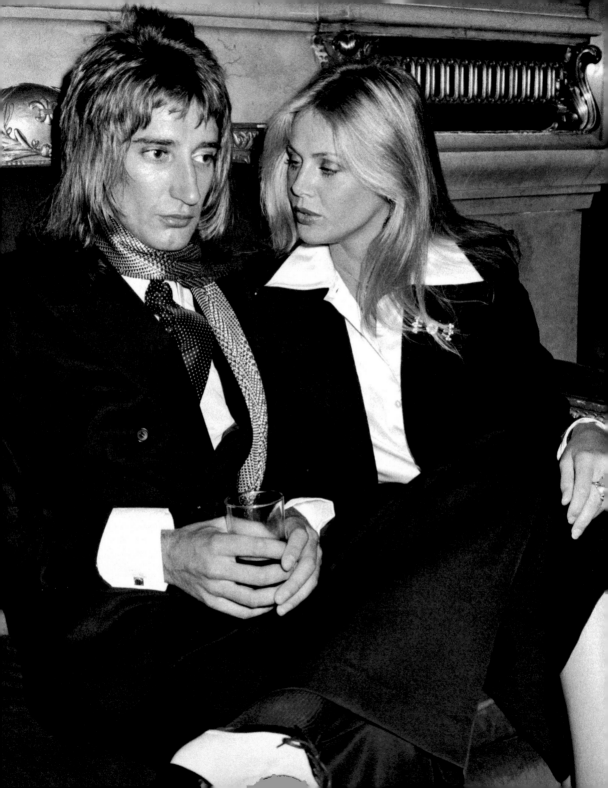

July 31, 1975:
Rod Stewart
and Britt Ekland
at the St. Regis
Hotel, NYC.

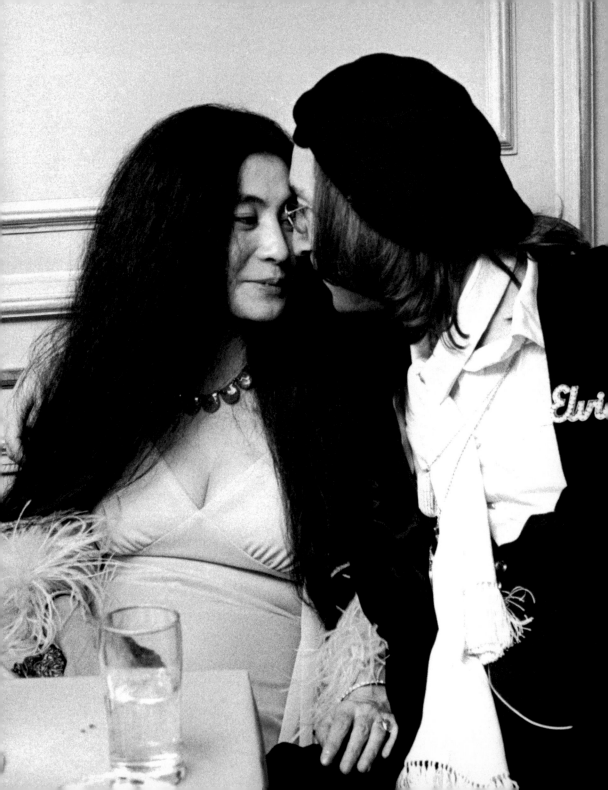

March 1, 1975: John Lennon & wife Yoko Ono at the
Grammy Awards.
12/8/80-11 pm: After a recording session at the Record
Plant, John Lennon & wife Yoko Ono were entering their
NYC apt. bldg., The Dakota, when Mark David Chapman, 25
of Honolulu appeared.(A security guard of the bldg. said
Chapman was crouched in an archway & was said to be
reading "Catcher in the Rye") Chapman shot Lennon 4 times.
Lennon with wife Yoko were rushed to Roosevelt hospital,
ina a police car & only a few minutes away from the
Dakota. Lennon was pronounced dead on arrival

X09-87

Sept. 8, 1983:
Forty year old superstar,
Mick Jagger was snapped in
Manhattan, while making his
rounds to Warner Recors and
the Hit Factory. The Stones
are busy putting the
finishing touches on their
latest LP and are in the
process of working on a
video for one of the
singles of the album. The
latest news on Jagger is
that his longtime
girlfriend and Ford model
is five months pregnant,
making this Mick's second
child. His first child was
daughter Jade, by his ex-
wife Bianca. There have
been reports of a possible
double ceremony, which will
feature Mick and Jerry and
fellow Stone, Keith
Richards and his gal, model
Patti Hansen. As I
photographed Mick, he said
to me, "Why do we have to
do this on the street.
Why don't you call up
the studio, so we can set
up a session?"

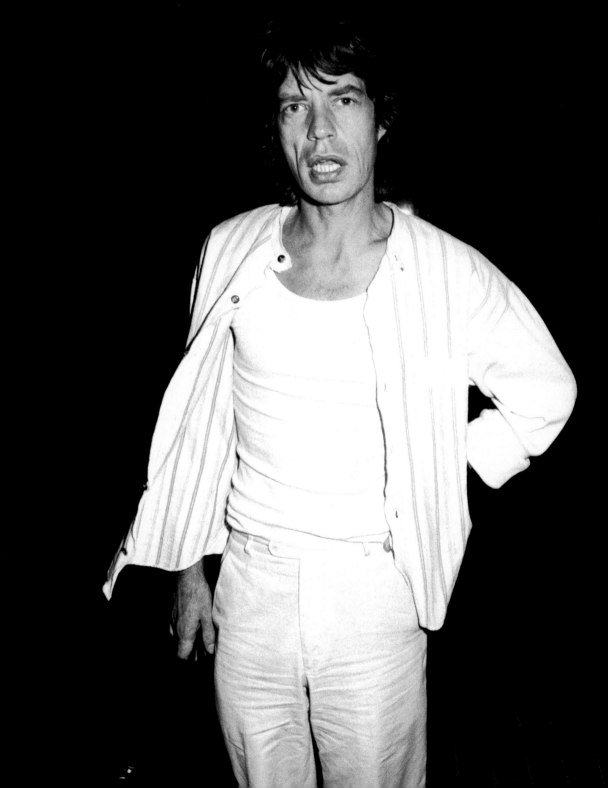

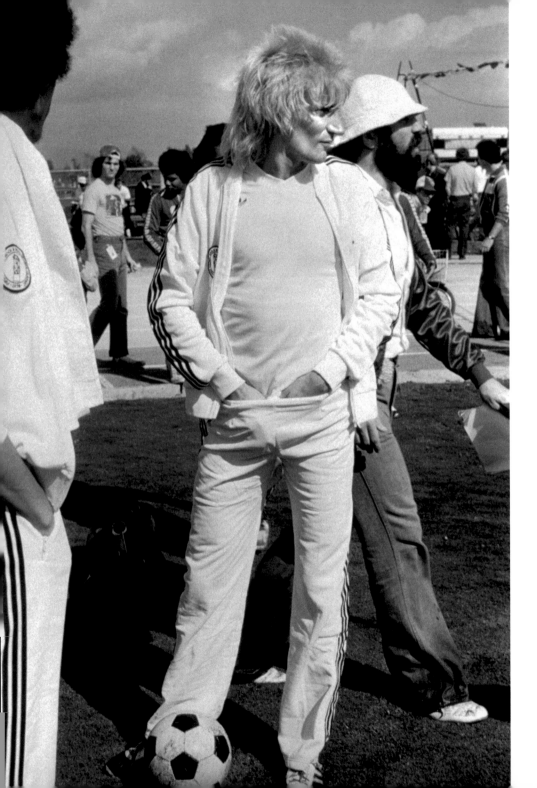

March 12, 1978: You don't need you're hands to play
soccer, so maybe Rod Stewart is playing another game
with his hands in his pants at the 1st Annual Rock-n-
Roll Sports Classics at the Univ. of Calif. in Irvine.

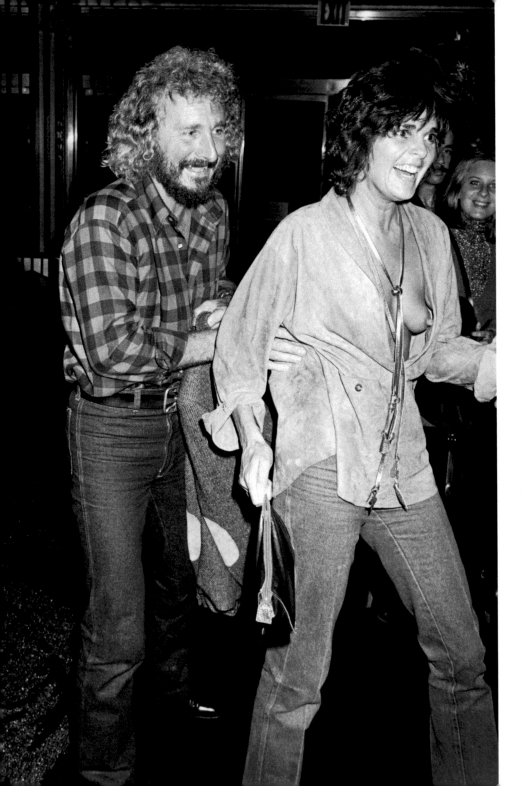

Oct. 10, 1978: Ali MacGraw enters
Studio 54 with producer, Larry
Spangler after having dinner at
Elaines Restaurant in New York
City.
Here's a 1983 update on Ali taken
from Interview Magazine:
Ali is now forty four years old
and about to make a comeback.
She will appear as a student at
school in Italy this winter when
ABC runs it's seven night, 21 hour
special, "Winds of War," based
on the Herman Wouk best seller about
World War II. Ali says that except
for an occasional trip to New York
and a TV documentary on the endan-
gered African lion, she's been liv-
ing something of a hermit's life in
Trancas, California, up the beach
from fashionable Malibu. "I have a
very simple small house, a lot
of animals, a great kid (Joshua
from Robert Evans) and some friends
in my own kind of eccentric, very
private lifestyle.

June 1, 1978:
"The Odd Couple:
Jack Lemmon & Walter
Matthau at "Tribute"
opening party at
Tavern on the Green,
New York City.

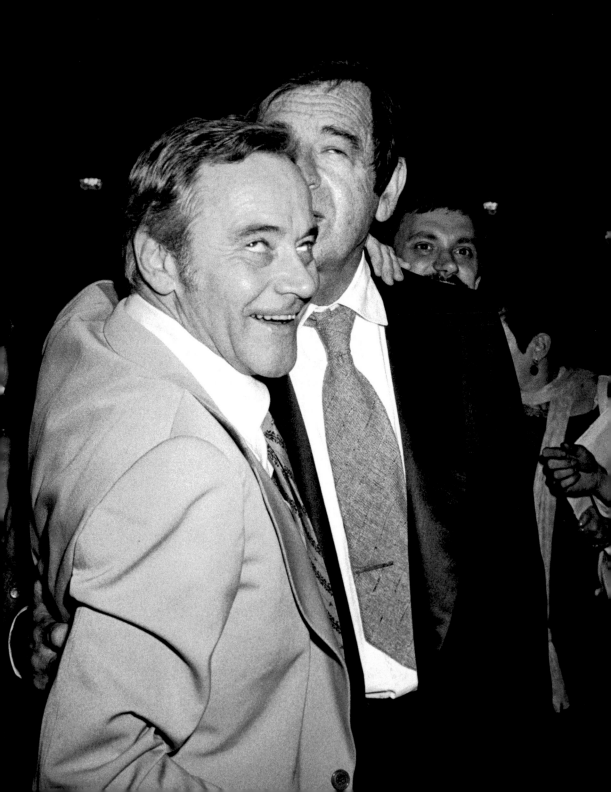

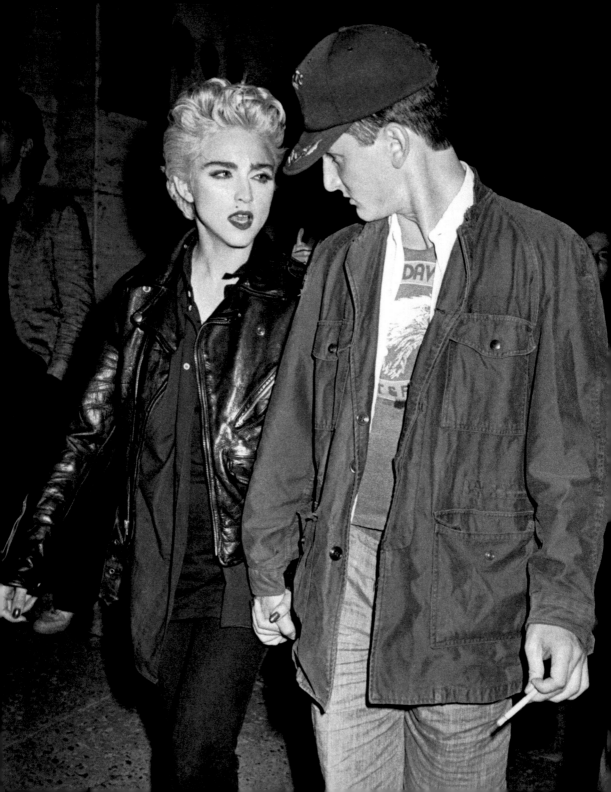

August 28, 1986: Bad Boy actor Sean Penn and
his wife Madonna were snapped as they departed
Lincoln Center following their performance in
David Rabe's workshop play, "Goose & Tom-Tom".
The celebrity duo headed for a late dinner
together at Columbus Cafe with friends. Penn
does everything possible to avoid being
photographed, he ducks his head and utters
obscenities at photographers.

March 29, 1979:
Lauren Hutton
at Roxy Rock
concert.

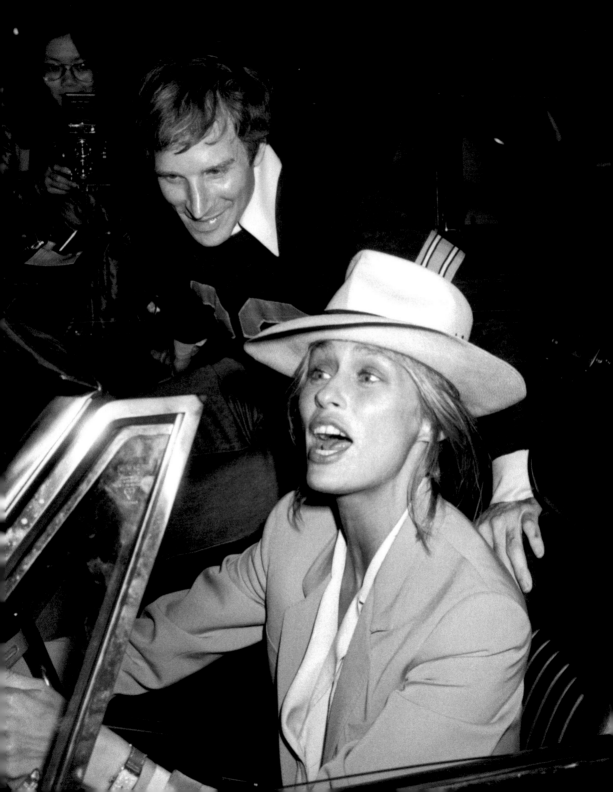

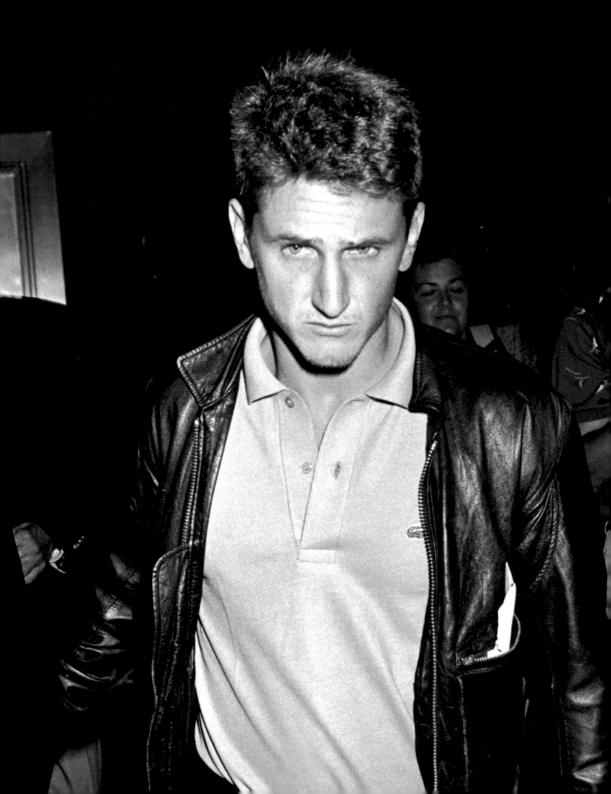

JUNE 27, 1987: "Bad Boy" SEAN PENN is
up to his old tricks again! Penn and
his wife Madonna were guests of Donald
Trump for the Tyson/Spinks fight in Atlantic
City at the Trump Plaza Hotel & Casino.
The ill-tempered actor, famous for physical
assaults on the press, took the opportunity
to do more than a little pushing and shoving
of his own. He shoved a tv cameraman
against the wall.and had to be restrained
by his bodyguard.

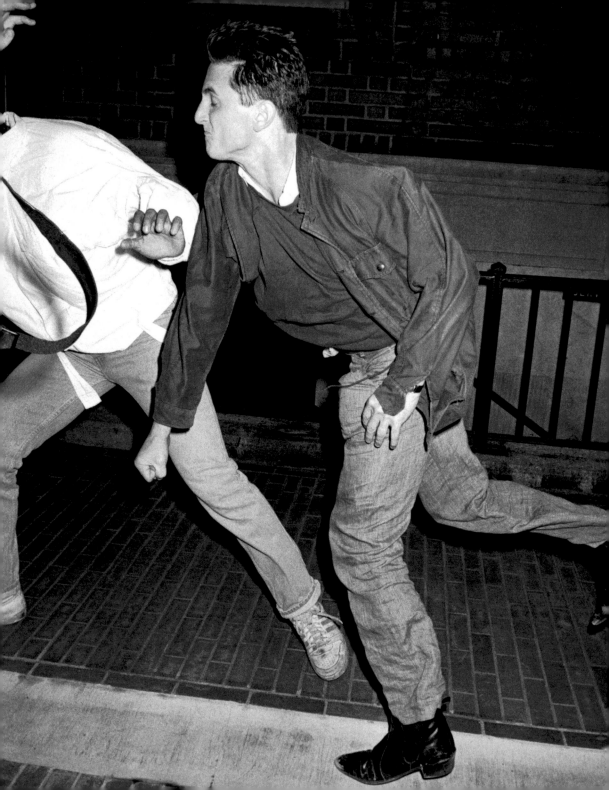

August 29, 1986: For the third time in recent months, Sean Penn, the celebrity bad boy has launched another spitting-hitting attack against photographers! In a rage, Penn spat on Anthony Savignano, nephew of Ron Galella, who spat back at the brat. Penn came out swinging and the altercation began for real while Savignano tried to dodge the violent attacker, then Penn landed a punch to the right eye of Vinnie Zuffante who was caught offguard.

By CYNTHIA FAGEN

BAD boy Sean Penn was at it again over the weekend — he got into a wild brawl with photographers.

It was the latest of Penn's frequent altercations with the press.

Penn and wife Madonna were on their way home from the Ginger Man restaurant on W. 64th Street toting a doggie bag after appearing in their second night invitation-only performance of "Goose and Tomtom" at Lincoln Center.

As a half-dozen photographers trotted after them to their W. 64th Street apartment building, Penn turned and spat. One photographer spat back.

"That's it!" Penn screamed. He swung the doggie bag and clocked shutterbug Anthony Galella in the face.

In a role he is well known for, Penn threatened the cameraman.

"You're on private property. You're dead," he exploded when Galella, the nephew of famed paparazzo Ron Galella, stumbled into the courtyard.

Madonna stood on the sidelines screaming, "Stop, Sean, stop," as her hot-tempered husband flailed away.

Penn lunged at Galella, who fended off Penn's punches at arm's distance.

Penn then caught Galella in a headlock and Galella grabbed Penn by the throat.

Madonna, hysterical, begged the half-dozen photographers to step in and "please stop them."

A doorman dashed out with a broom and tried to separate them.

As they were dragged apart, Penn wheeled around and punched another unlucky shutterbug with a right hook, catching him under the left eye.

The scuffle finally broke up and the Penns scrambled to the doorway screaming epithets.

Nobody was hurt.

THE NEW YORK POST September 1, 1986

April 3, 1974:
Bianca Jagger
at the Beverly
Wilshire Hotel.

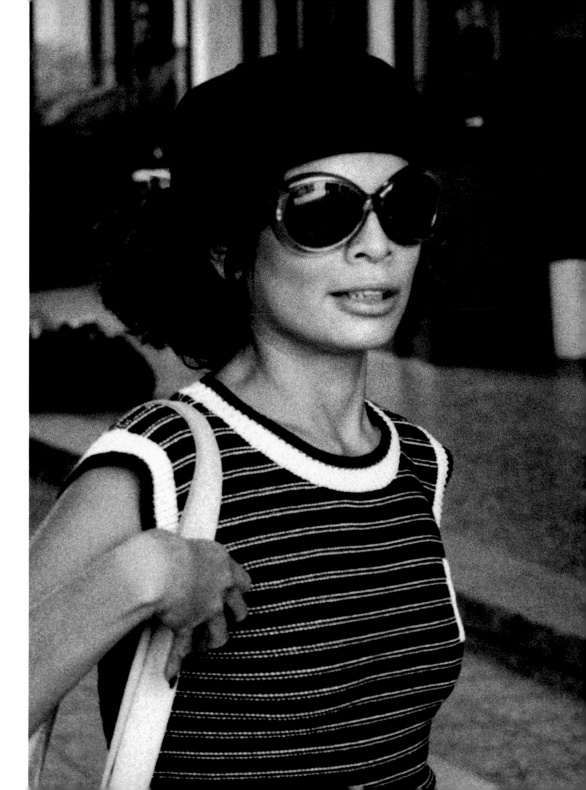

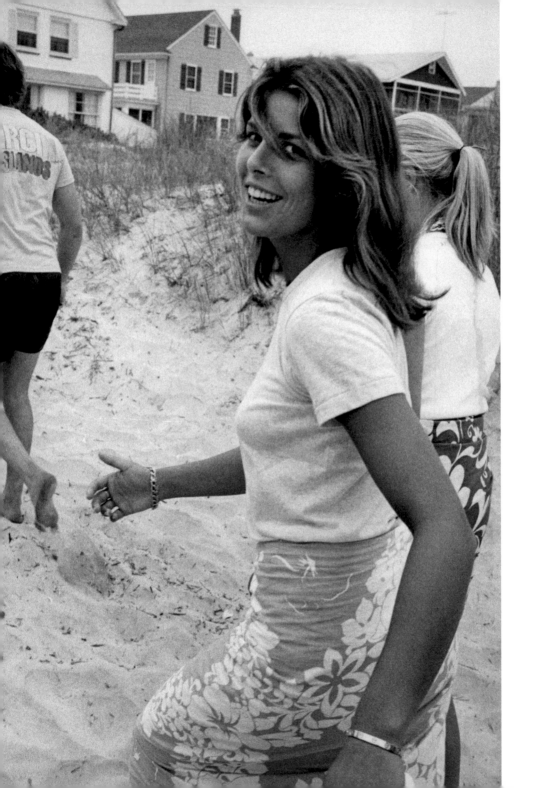

July 30, 1978:
Princess Caroline
at Ocean City
Beach.

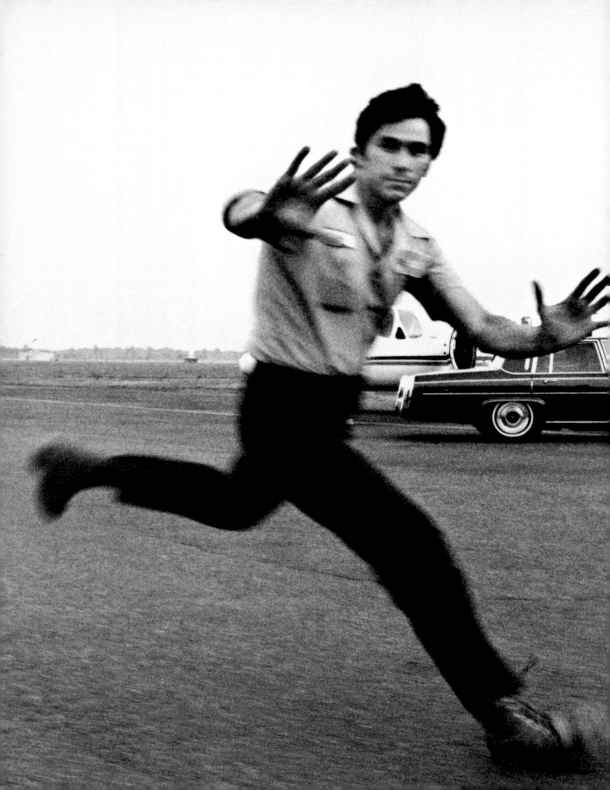

July 8, 1981:
Airport personal
at Teterboro Airport
in New Jersey
try to stop
photographer
Ron Galella
from following
John Travolta
& Brook Shields
as they board
Travolta's
private jet
for unknown
destiny.

The Brando
saga

May 25, 1968:
The second time I
photographed Brando
was at the SHARE
Benefit party at the
Santa Monica Civic
Auditorium.

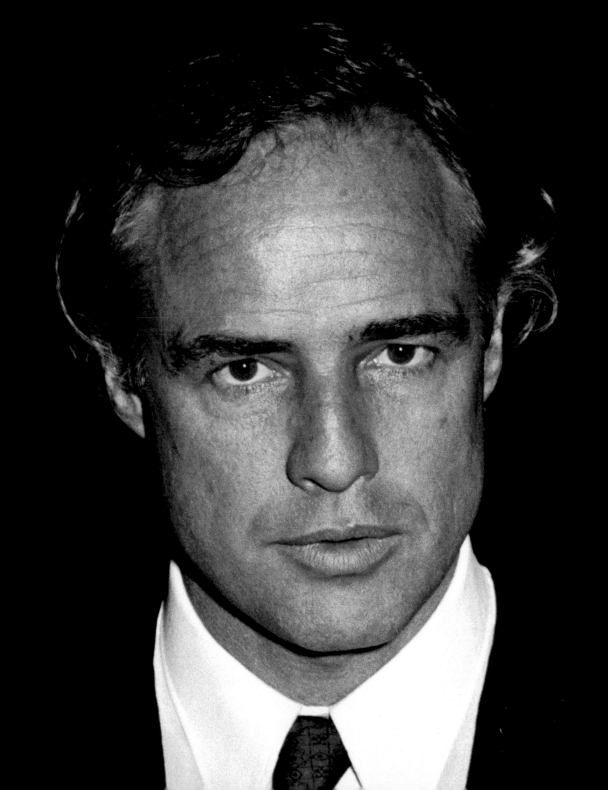

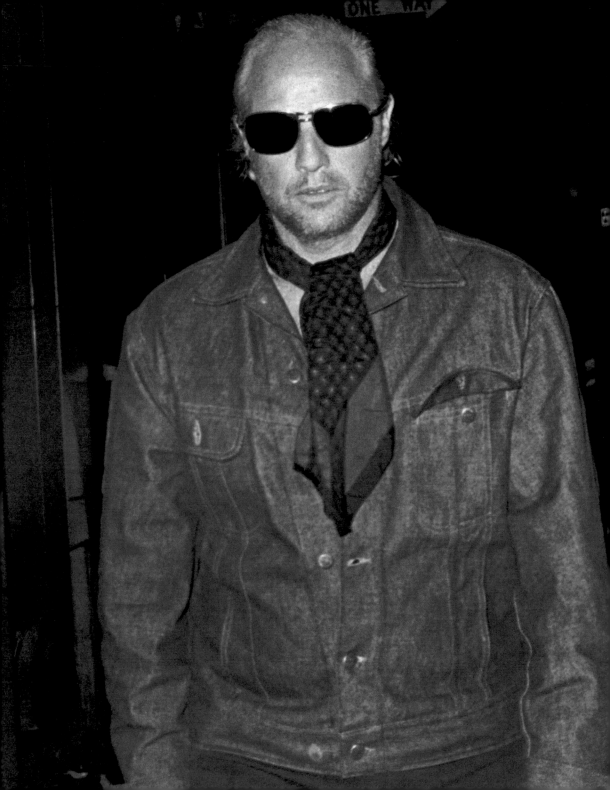

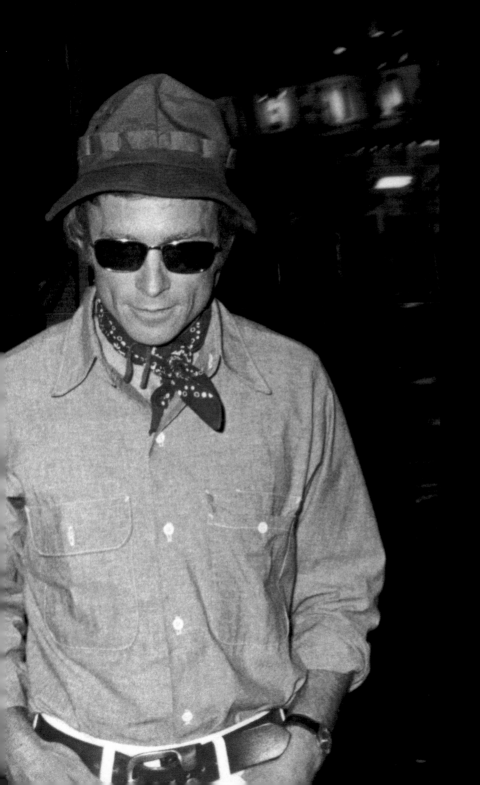

June 12, 1973: Marlon Brando taped the Dick Cavett Show at ABC TV studios in New York City. I followed the duo to Chinatown and after snapping this and a dozen other frames, Brando waved me over. "what else do you want that you don't already have?" I asked if he could please remove his sunglasses (it was night time). He said "No" and then wham! Brando threw a right punch to my lower jaw, breaking it along with 5 teeth. The next morning Cavett took Brando to NY Hospital oi Special Surgery with an injected, swollen rigt hand. an out-oi court settlement for $ 40,000 was reached later in my favor to help pay for the extensive dental bridge which has been replaced 3 times.

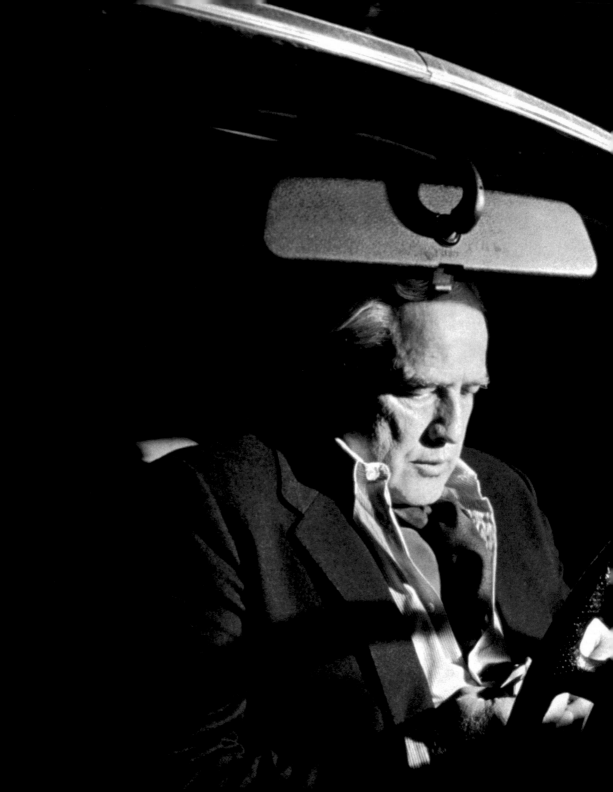

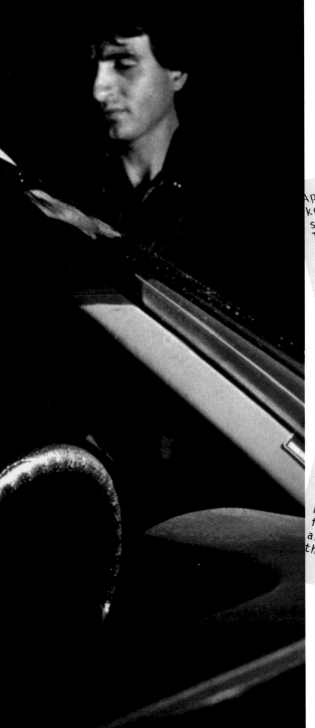

April 17, 1983: Marlon Brando, who keeps a home in Hollywood Hills, but spends most of his time on his Tahitian Island, made a rare public appearance on the West Coast when he took a new exotic girlfriend to a Los Angeles Restaurant. The reclusive actor had a romantic dinner with a pretty petite brunnette at Trader Vics , a Polynesian Restaurant. Marlon and date, who-according to observers couldn't have been more than twenty years old, were the last to leave the place at closing.

Robert Towne is planning a sequel to the very successful "Chinatown" called "Two Jakes." Towne won an oscar for the screenplay of the original. Now he's reportedly got Marlon Brando to star for $5 million. He's also got Jack Nicholson and Dustin Hoffman for another 5 million each and Jane Fonda for 4 million. Brando's daughter Mahia, will follow in her fathers footsteps and will make her film debut in the coming "Sandstone" feature.

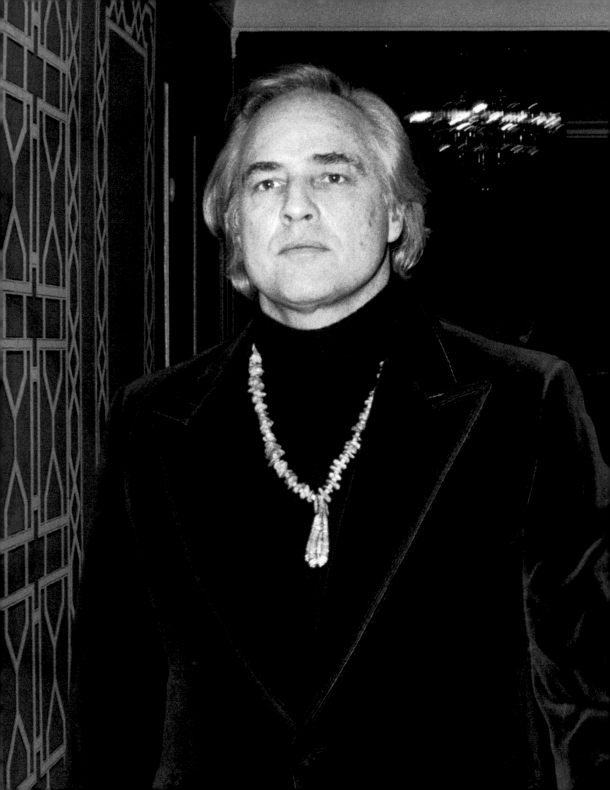

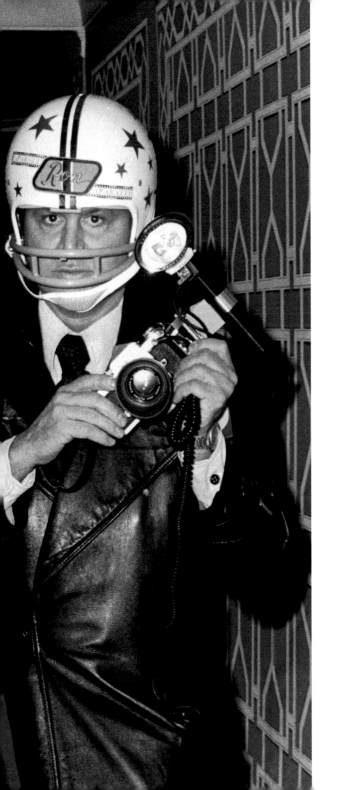

Nov. 26, 1974:
Marlon Brando arriving
at a press conference to
annouce the First Gala
benefiting the American
Indian development
Association at the
Waldorf Hotel in New
York City. Photographer
Ron Galella was barred
from the event, but
another photographer
Paul Schmulbach got this
shot of Ron Galella
wearing a helmet in the
corridor of the hotel as
Brando arriving at the
press session. When he
saw Galella, Brando
miled, but kept a
straight face and no
words were exchanged.
A year earlier,
Brando slugged Galella
in Chinatown, breaking
his jaw and knocking
out five teeth. An
out-of-court settlement
for $40,00 was reached
in Galella's favor
later. But Galella took
no more chances in his
encounter with the
powerful superstar, he
came equipped with his
paparazzi helmet!

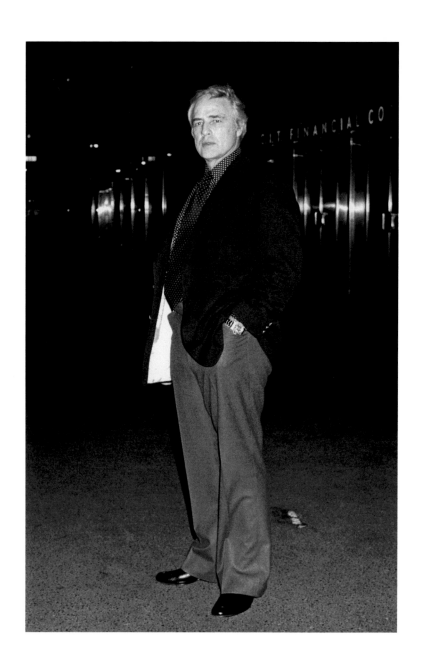

Nov. 6, 1977

After two weeks of waiting for the so elusive, enigmatic Marlon Brando at the Pierre Hotel, he finally walked out the front door and said to us, "Can we take the pictures now and be done with it". Then Brando said to Galella, "What are you running for, take your pictures, tell me what you want". I mentioned to Russell Turiak (a freelance photographer who took this picture) to ask for a shot of me handing Brando the peacepipe. Russell asked and Brando refused. Then I asked if I could shake his hand and he said, "O.K.".

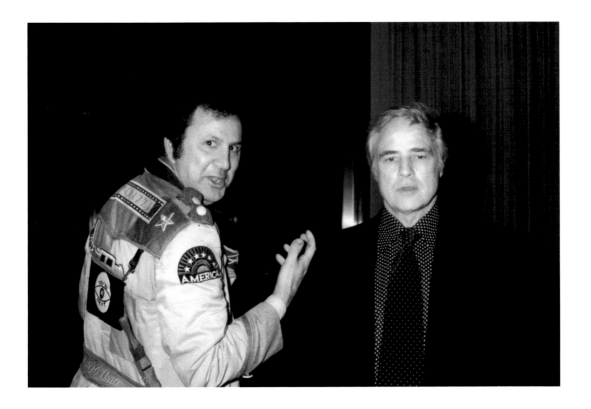

Jackie obsession

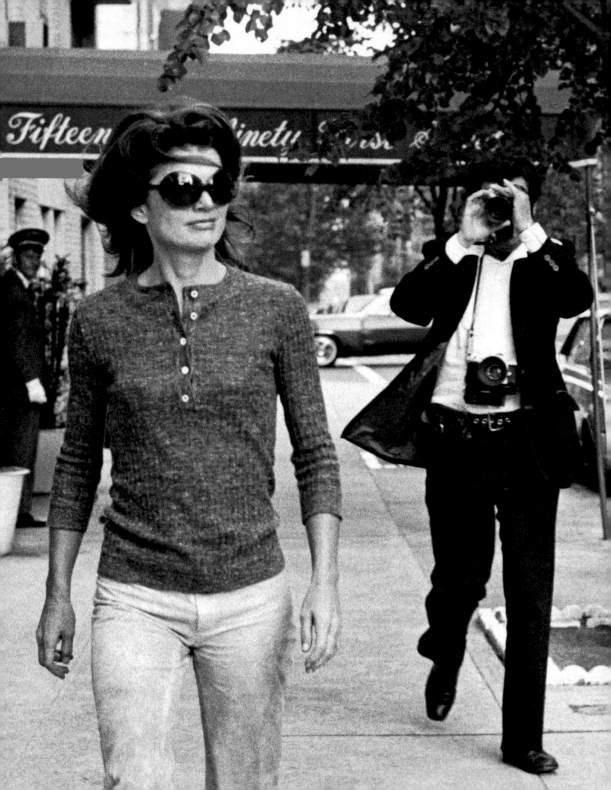

Oct. 7, 1971: Jackie walking on Madison Ave. while
Ron Galella took several photographs of her.
Photo credit: Joy Smith

October 7, 1971: It was late in the afternoon around 4:30 pm. I finished photographing a model Joy Smith, who needed pictures for her portfolio. I wasn't getting paid for it, so I thought I might as well shoot in Central Park across from Jackie's apartment in case I get lucky, and I did! Upon leaving the park I saw Jackie leave her apartment on 85th Street and head towards Madison Avenue. Joy could not believe it was Jackie! We were behind her at 85th St. and Madison Ave. Jackie made a left going north. I decided not to run in front of her, if I did she would have put on those dark glasses. So we hopped a cab to get in front of her so she couldn't see me. "Follow that woman!" I told the cab driver. For once, Jackie's instincts were all wrong; instead of turning away she turned right towards me after hearing the first two clicks of the camera from the cab window. After getting out of the cab she spotted me and immediately put on sunglasses. I then handed Joy one of my cameras with a wide angle lens and prefocused to 15 feet. I told her to get the two of us together. Both Joy and I were clicking and laughing until Jackie furious turned and said, "Are you pleased with yourself?" well I knew then to stop and said "Thank-You!" This is my favorite photo because it captures the qualities of the paparazzi style; offguard, unrehearsed, spontaneous; the dramatic soft backlighting and the over-the-shoulder composition shows her at her sexiest. She was casually dressed, wore no makeup and her hair was windblown which all added up to natural beauty. This is in contrast to the usual studio style picture. All the natural elements worked for me, including a little luck! Da Vinci had his "Mona Lisa", and I have my "Windblown" Jackie, my favorite, most famous photo of Jackie.

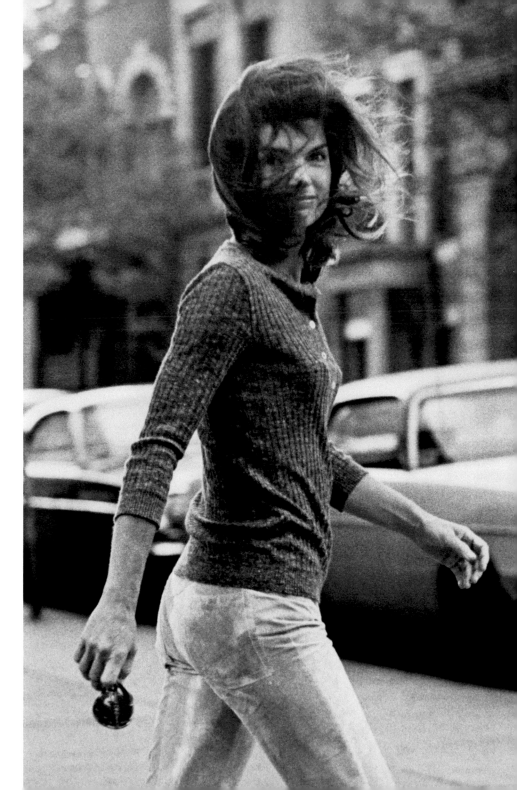

Sept. 24, 1969: After taking the bicycle photos on the pedestrian path, Jackie recognized me and said, "Oh! It's you again". While I was taking pictures of them waiting at the corner for the light to change, John Martin, a fan (behind Jackie), witnessed Jackie saying to secret service agent, Mr. Connelly, "Smash his camera". "You've had enough", said Connelly, while blocking me from taking any more pictures. Jackie then crossed 5th ave. At 85th st. to meet secret service agents, John walsh and James Kalafatis. She ordered them to arrest me. They ran after me and forced me into their car, then took me to the 19th police precinct where only John walsh got out of the car. He later charged me with harassment of Kalafatis at the police station because I tried to get out of the car to enter the police station to get charged. When the case came up for trial in NYC criminal court, the judge said, "I'll say this, I'm not certain who was being harassed, case dismissed. This was a false arrest". Later, at the big trial, in federal court, Jackie testified and her lawyer paid a photographer to testify that I jumped on the path, frightened Jackie and John, and they almost fell off their bikes. I think my pictures speak an obvious truth instead of her lawyer's thousand words to twist the truth. It took 26 days in court to do just that!

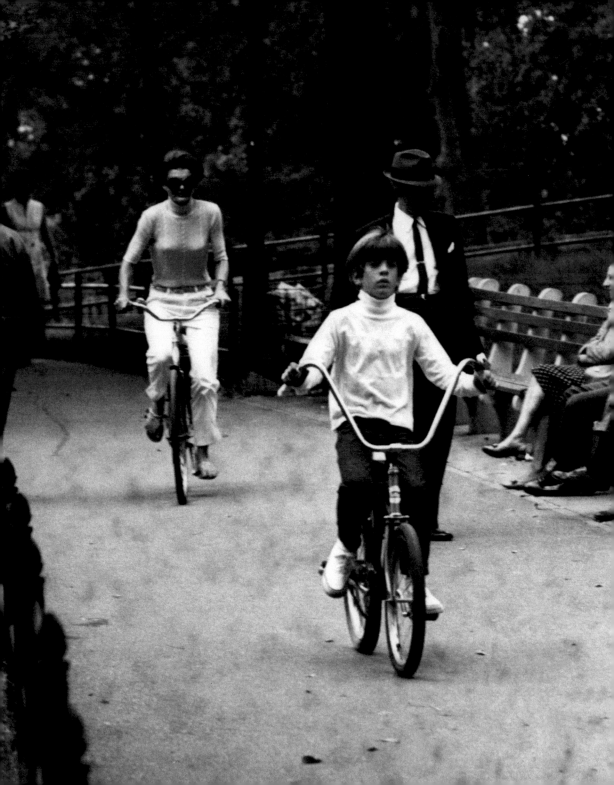

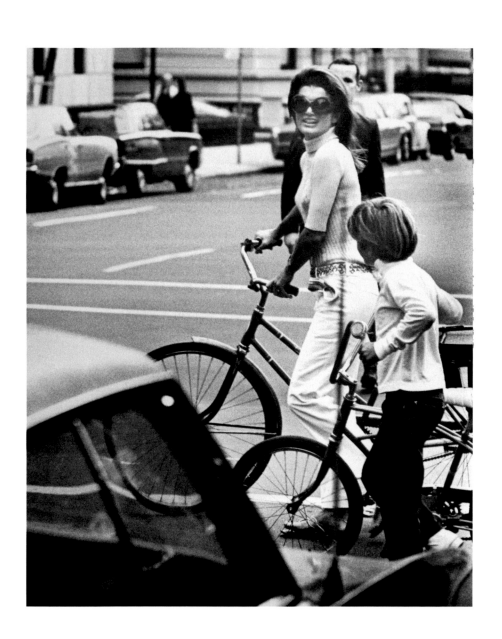

1969

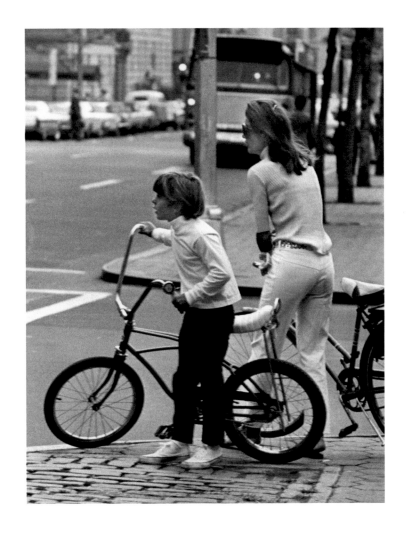

Jackie and John
going home after
bike riding
in Central Park.

Nov 8, 1968:
Jackie returning
to her NYC apt.
after marrying
Greek shipping
tycoon Ari
Onassis.

August 24, 1970:
Jackie with
sister Lee and
niece shopping
in Capri, Italy.

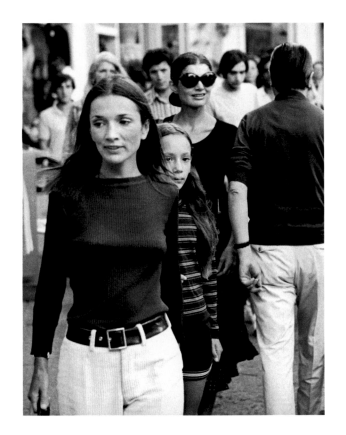

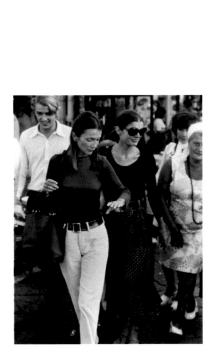

Here in this photo we have Tony and Andrea Radziwill and there alongside Jackie,
is Ron Galella disguised as a U.S. sailor. When Jackie recognized Galella, she said
to her sister: "There is that man from New York City again!".

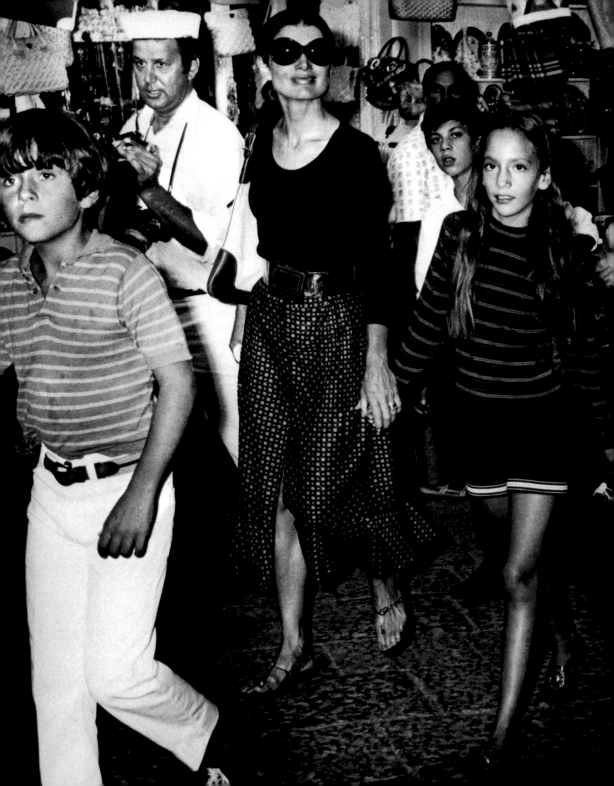

Aug. 24, 1970: Capri,
Italy. My sailor disguise
didn't work this time.
At an outdoor cafe Jackie
asked the waiter to call
the police and have me
arrested.

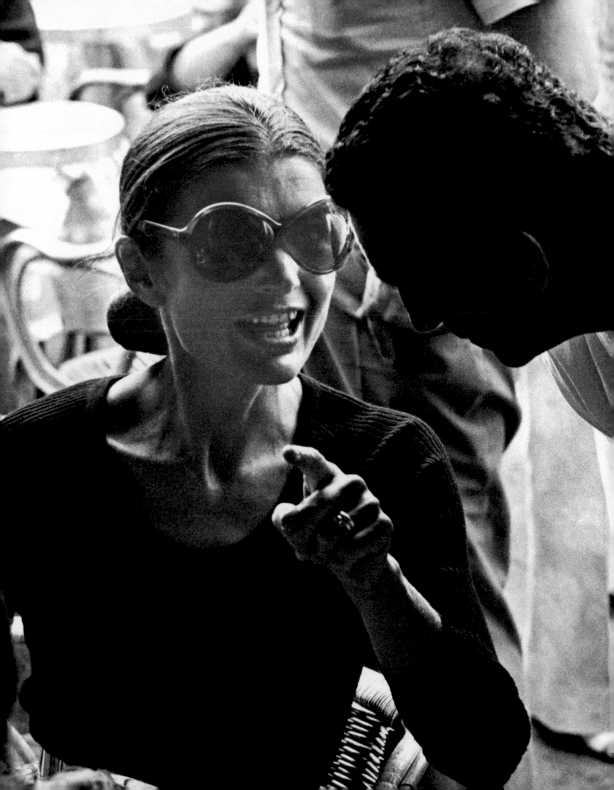

August 31, 1980: Tanned and macho, John F. Kennedy, Jr. spent Labor Day weekend
sailing with his cousins at the Kennedy Compound in Hyannis, Mass. John had just
returned from a summer spent touring Africa and was getting ready to begin his
Freshman year as a student at Brown University in Providence, Rhode Island. He
plans to pursue a legal career.

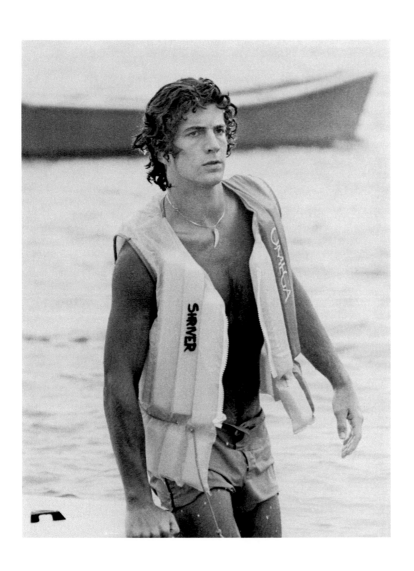

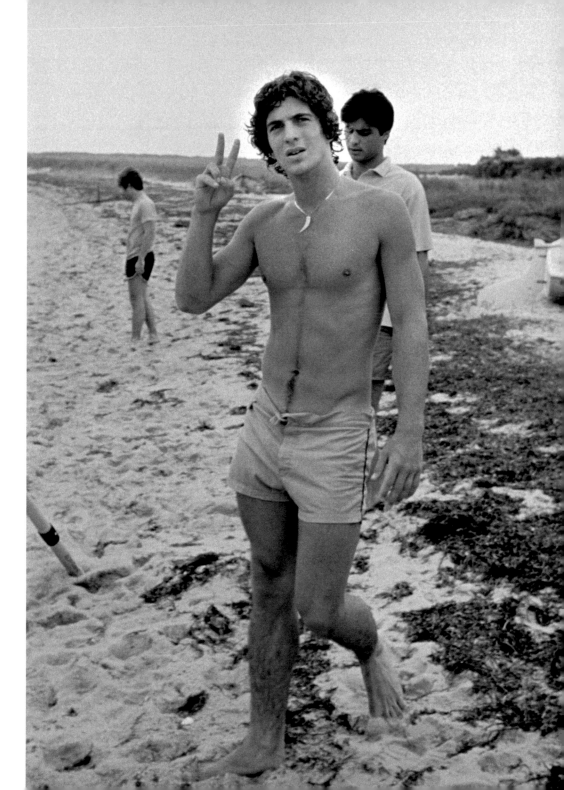

Nov 12, 1970:
E. 56th NYC
Agent Mike
Dolphin blocks
Ron from taking
photos of Jackie
leaving private
screening of
Peter Beards
film on Africa.
Peter escorted
Jackie, Caroline
and John JR.

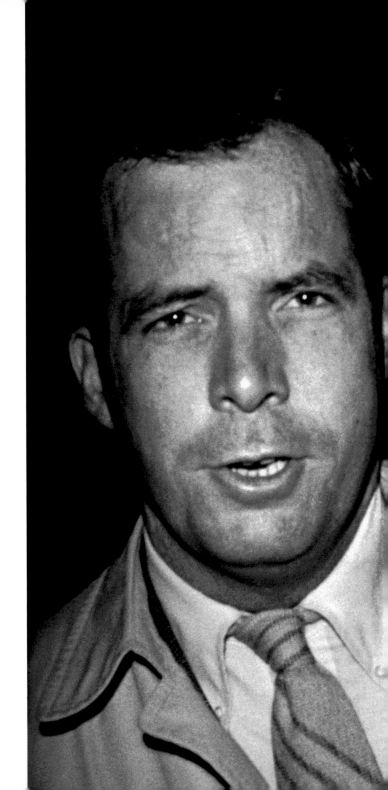

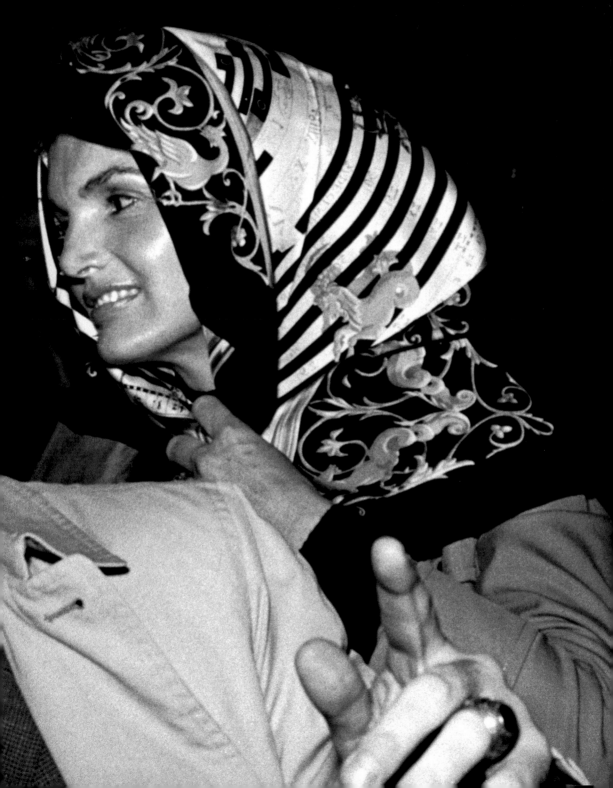

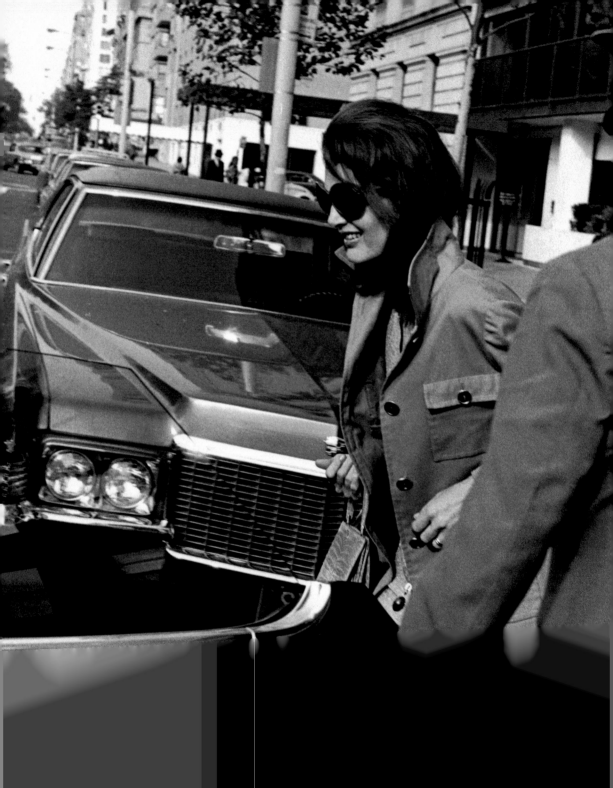

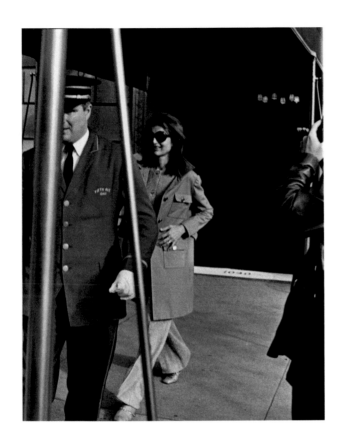

Jackie leaving her NYC
apt. to go shopping
at Bonwit Teller.

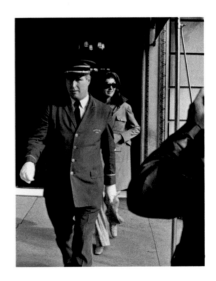

Oct. 15, 1970

July 1st,1971 NYC: Jackie, Ari
and Pat Lawford leaving 21 Club.

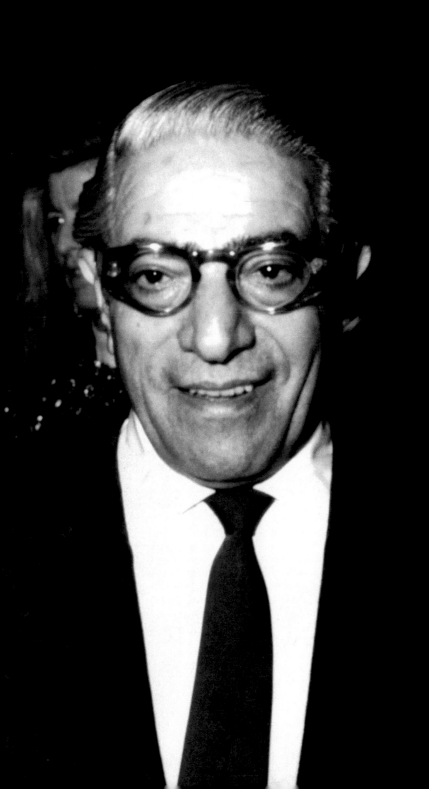

May 6, 1969:
Jackie entering her
car after shopping
at a Peapack,
New Jersey store.

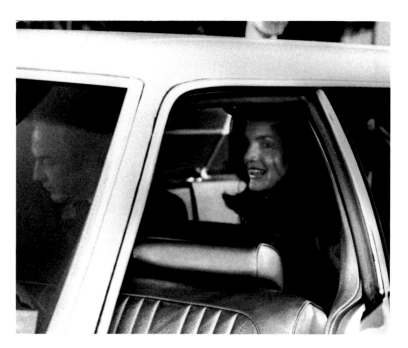

March 15, 1975 Jackie en Route to Kennedy Airport during transfer from limousine
to Olympic station wagon, with agent. She's going to Paris for Onassis funeral.

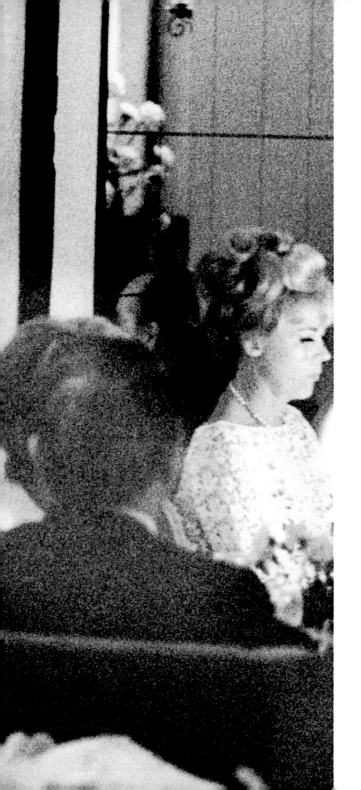

June 9, 1969:
Jackie and Ari at
La Cote Basque
Restaurant, NYC.

May 11, 1969
(Mother's Day):
while I was hiding
behind the corner of
Jackie's apt.
building I was about
to photograph her,
she saw me and hid
her face with a
bouquet of flowers.

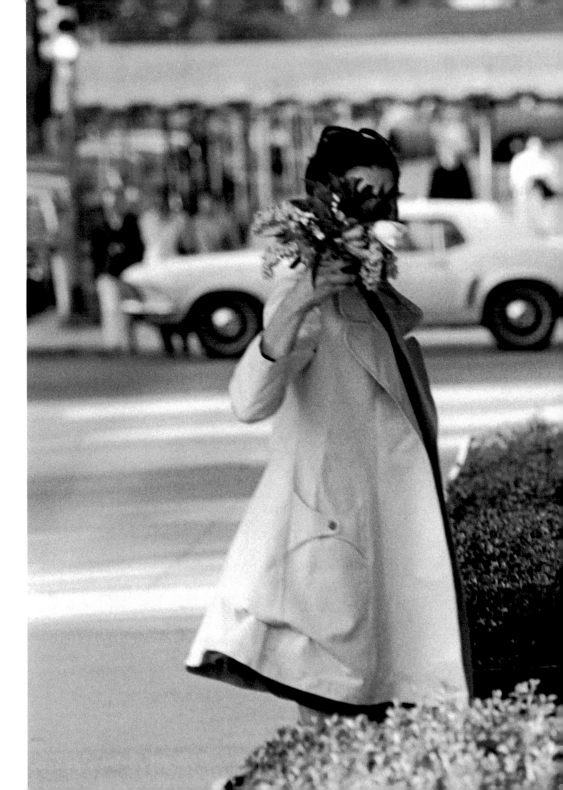

BOOKS AND MAGAZINES:

"Jacqueline" by Ron Galella 1974: Sheed and Ward, Inc.

"Offguard: A Paparazzi Look at the Beautiful People" by Ron Galella 1976: McGraw Hill Book Company

"Secrets of the Paparazzi" American Photo Magazine July/August 1992

"The Photographs of Ron Galella 1965-1989" 2001 Greybull Press

"Photographs by Ron Galella" Paul Kasmin Gallery June-August 2002 Catalog with 175 photos from exhibit

"Ron Galella Exclusive Diary" Photology 2004

EXHIBITIONS AND LECTURES:

Soho Gallery, New York City, 1972

The 17th Wilson Hicks International Conference on Visual Communications at the University of Miami, 4-13-73

G.Ray Hawkins Gallery, Inc., Los Angeles, 1976

Rizzoli Gallery, New York City, June-August 1976

Union Carbide Exhibition, New York City, March-April 1977

William Lyons Gallery, Coconut Grove, Florida-60 B/W prints from "Offguard" book May-June 1980

The Ohio State University in Columbus, OH, May 20, 1981

Photo '84 District News at New York Coliseum, December 2, 1984

The Learning Annex Photo Course in New York City, January 8, 1987

Octagon Club, Disco Photo Exhibit, New York City, October 28, 1987

Nikon Gallery, New York City, 1993

Serge Sorokko Gallery, New York City, 1997

The Warhol Museum in Pittsburgh, Pennsylvania, June-September 2002

Paul Kasmin Gallery, New York City, June-August 2002

Holt-Renfrew/Flick Exhibition, Toronto, Canada, September-December 2003

Photology, Milan, Italy, September-November 2004

EXHIBITION:

Ron Galella "Exclusive Diary"
Photology, Milan 28 September – 20 November 2004

Curated by Davide Faccioli

With the contribution of WP Store

Press Office: Alessia Paladini, Photology
 Raffaella Ferrari, WP Lavori in Corso

PUBLICATION:

Ron Galella "Exclusive Diary" – first edition: Photology September 2004

Graphic Concept: Davide Faccioli

Layout, CTP & Printing: Grafiche dell'Artiere, Bologna

Many thanx to Vania Brisolin, Laura Coppa, Betty Galella, Roberto Grazzini, Carmen Masi, Mimmo Masi, Alessia Paladini, Roberto Randazzo.

Distributors:
USA-South America
 DAP-Distribution Art Publisher, 155 Sixth Avenue-New York,NY 10013-1507-USA
 Tel. +12126271999 Fax +12126279484
U.K.
 Art Data, 12 Bell Industrial Estate
 50 Cunnington Street-London W4 HB-Uk
 Tel. +441817471061 Fax +441817422319
Europe
 Idea Books, Niewe Herengracht 11-1011 RK Amsterdam-Netherlands
 Tel. +31206209299 Fax +31402440393
Italy
 Librimport, Via Biondelli 9 – 20141 Milano-Italia
 Tel. +390289501422 Fax +390289502811

Photology s.r.l.
Via della Moscova 25 – 20121 Milano
Tel. +39026595285 – Fax +3902654284
www.photology.com – photology@photology.com

First photo: "Ron walking up Madison Av." (detail) New York, Oct. 7, 1971
Second photo: "Andy Warhol at Jimmy's" New York, Oct. 18, 1973
Third photo: "Jay Heatherton at the Waldorf Astoria Hotel" NYC, May 24, 1975

PHOTOLOGY EXHIBITION CATALOGUES

1992	HELMUT NEWTON, V.I.P. Very Important Portraits.
	Texts by DAVIDE FACCIOLI and CLAUDIO MARRA
1992	IRVING PENN, People in Passage.
	Texts by CLAUDIO MARRA and MARISA BERENSON
1993	ROBERT MAPPLETHORPE, Secret Flowers.
	Texts by CLAUDIO MARRA and VITTORIO SGARBI
1993	ANDRÉ KERTESZ, Paris.
	Texts by CLAUDIO MARRA and BETTINA RHEIMS
1993	JACQUES-HENRI LARTIGUE, Madame France.
	Texts by CLAUDIO MARRA and MARCEL PROUST
1993	HERB RITTS, Photographs.
	Texts by DAVIDE FACCIOLI and RICHARD GERE
1994	MARIO GIACOMELLI, Prime opere.
	Texts by GIULIANA SCIMÉ and JOHN SZARKOWSKI
1994	MARIO DE BIASI, Neorealismo e Realtà.
	Texts by ITALO ZANNIER and DAVIDE FACCIOLI
1994	BRUCE WEBER, No Valet Parking.
	Texts by BRUCE WEBER, SHERRIL and G. SUTTON
1995	FRANCO FONTANA, Paesaggi 1970-1995.
	Texts by ACHILLE BONITO OLIVA and EZIO RAIMONDI
1996	ANNIE LEIBOVITZ, Ritratti 1980-1995.
	Texts by JAMES DANZIGER and ROBERTO D'AGOSTINO
1996	TAZIO SECCHIAROLI, The Original Paparazzo.
	Texts by SOPHIA LOREN and ENRICO GHEZZI
1996	AZIZ+CUCHER, Unnatural Selection.
	Texts by PATRICK ROEGIERS and FABRIZIO CALEFFI
1998	NOBUYOSHI ARAKI, Tokyo Nostalgia.
	Texts by ETTORE SOTTSASS and GIAMPIERO MUGHINI
1998	ANDRES SERRANO, A History of Sex.
	Texts by FRANCESCA A. MIGLIETTI and STÉPHANE NAPOLI
1999	GIACOMO COSTA, Land(e)scape.
	Texts by GIACOMO COSTA and PIETRO COSTA
2001	JACK PIERSON.
	Designed by JOHN CHEIM and JACK PIERSON
2001	DAVID LACHAPELLE.
	Text by DAVIDE FACCIOLI

PHOTOLOGY BOOKS

2000	100 al 2000: il Secolo della Fotoarte.
	Texts by 100 writers
2001	MARIO GIACOMELLI.
	Texts by GERMANO CELANT and ALESSANDRA MAURO
2002	GIAN PAOLO BARBIERI, A History of Fashion.
	Text by MARTINA CORGNATI
2003	Claudia Cardinale - Alberto Moravia, Dialogo e fotografie.
	Text by ALBERTO MORAVIA
2003	A Flash of Art. Fotografi d'azione a Roma 1953-1973.
	Text by ACHILLE BONITO OLIVA
2004	ETTORE SOTTSASS.
	Text by ACHILLE BONITO OLIVA
2004	RON GALELLA, Exclusive Diary.
	Text by RON GALELLA

at Roberta Flack party, at
1, 1967: Carol Channing at Premiere of "Thorou
Barbra Striesand was among the firstnighters to attend the opening of
Ca. Barbra "was" accompanied by the
But sly "babs" and Richard managed t
1969: Sammy Davis, J
a party which followed Sammy was mobbed by Hollywood friends, actress
February 16, 1984:
ters Elaines, after Woody had already gone inside, Mia & Woody play the
ess Stephanie of Monaco was snapped near Bergdorf Goodman in Ne
and her new brother-in-law, Stefano Casiraghi went to visit his
14, 1982: Grim faces must be the
hotographer Ron Galella had little success in coaxing smiles out of thi
group members Chris Stein, the lead guitarist Deborah Harry who is Chris's maybe it's Rea
and lover and lead singer and
of their national tour, Blondie performed numbers from their new album,
e's own Mt. Everest. Andy Warhol was on hand for the concert and came b
Andy Warhol chats with
Hughes at the Museum of Modern Art in New York City. They were among the
ary 22, 1987 update: WARHOL DIED OF A HEART ATACK AT THE AGE OF 58. His
GLORIA VANDERBILT who is a close friend
an evening tribute at New York City's Philharmonic Ha
redit: Ron Galella /
LLO RIVIERA were taken following three hours of reconstructi nose surgery at the private office
Zoom Zoom Nightclub is the hottest of hot spots for la
e legendary French beauty departed the club with an
hidentified companion.
Globe-trotting
the South of F
y 16, 1967: Richard Nixon at
hard Gere who's about to "reveal all" with friend Priscilla at "The Cha
ess, born Leslie Hornby, was originally called
28, 1967: Twiggy at Bert Stern St
4: A cigar smoking Tom Jones was snapped at the Beverly Wilshire Hotel in Beverly Hills, Ca. where
star was born Thomas Jones Woodward on June 7, 1940 in Pontypridd, Wales.
asked Warren Beatty
Jerry Hall at Rob
could kiss him & he replied, "No, I have to watch out for Galella!" a
of "Thoroughly Moder
DBER 7, 1971: Late one afternoon I saw Jackie walking up Madison Avenue in New York City without
glasses. This is my favorite photo because it captures the qualities of the paparazzi style; or
Jackie. I dressed warm to make up and her hair was "Lindtown which I added up" Jackie had
discovered me, she put on her glasses and quipped "Are you pleased with yourself?" DaVinci had
September 24, 1969:
Agen
ackie and John going home after bik
Nov 8, 1968: Jackie returning to her NYC apt. after marrying Greek shipping tycoon Ari Anassi
h 15, 1975 Jackie en Route to Kennedy Airport during, tra
l limousine to Olympic station wagon, with agent. She s g
ick jagger was snapped in Manhattan, wh
8, 1962: Forty year old superstar Mick Jagger was snapped in Manhatt
ishing touches on their latest LP and are in the process of workin on a
Ford model is five months pregnant, making this Mick's second chil
y do, we have to do this on the stree
Patti Ha
don't you call up the studio, so we can set up a session
1968: Marty Allen eyeballs those rocks! remarking "Diamonds
iggy at Bert Stern Studio
The event was for the benef
sh model and aspiring actress, bor